HEARTS of DARKNESS

Also by Don McCullin

THE DESTRUCTION BUSINESS
IS ANYONE TAKING ANY NOTICE?
HOMECOMING
THE PALESTINIANS

HEARTS of DARKNESS

PHOTOGRAPHS BY
DON McCULLIN

WITH AN INTRODUCTION BY
JOHN LE CARRÉ

ALFRED A. KNOPF
NEW YORK 1981

THIS IS A BORZOI BOOK
PUBLISHED BY ALFRED A. KNOPF, INC.

Photographs © Donald McCullin 1980

Introduction © Authors Workshop AG 1980

Some of these photographs have appeared in
The Palestinians published by Quartet Books,
Homecoming published by Macmillan and
The Sunday Times. Grateful thanks and
acknowledgements are hereby made to these sources.

L. C. Catalog card number: 80–83730
ISBN: 0–394–51476–9

Printed in Great Britain
First American Edition

CONTENTS

HEARTS of DARKNESS

INTRODUCTION
by
John le Carré

When I was asked to write this introduction, all I knew of McCullin was his photographs, which I thought extraordinary, and his reputation for courage, lavishly conveyed to me by his fellow journalists. But the photographs conveyed that anyway. I had also read his own text to *Homecoming*, his collection of photographs of England. It was a touching, rather distraught piece of writing – or better, speaking, for it was clearly dictated – a declamatory confession of guilt, insecurity and indignation, all banged off in a single reel, demanding that we recognise what strikes me as self-evident of an artist anyway – but was not at all self-evident to him – namely that his work is an externalisation of his own fragmented identity. I was slightly embarrassed by his frankness, and a little cross with his publishers for letting him indulge it. I even wondered whether McCullin, stricken, as he says, with guilt at his own success at the expense of other people's agony, was playing a game of dare with his public, challenging us to reject him because he was not a hero, not an artist, just a jet-lagged, battle-weary eye.

That was the sum of my awareness of him, and of my qualification for writing about him. When I am researching locations for a novel I will sometimes take a camera, but I am no sort of photographer. On my travels I have been to a few of McCullin's places, though not, thank God, too close to his Hearts of Darkness. My entire experience of battle would fill a single day for him. I have also, of course, seen that ever-growing polyglot rabble of so-called war correspondents and so-called photographers which swarms – these days in charabanc-loads – wherever there is a prospect of blood, starvation, fire or pestilence. In the line of research, or compassion, or accident, I have held the heads of some of these and listened to their drunken fantasies about each other, and consequently, by extension, about themselves. It's high time somebody updated *Scoop*.

I have also, to my joy, known a few of the other sort, and they are worth the rest.

My response to his photographs, however, had for the last six or seven years been decisive. I found them electric, I found them haunted and at times unearthly. I might not care that much for his confessions, but I could well understand that his work was the product of a restless and slightly puritanical nature, deeply ill at ease with the world's condition, and his own.

I decided that the simplest thing I could do was ask McCullin for an interview: to point the writer's lens at him much as he has pointed his camera at countless of his fellow creatures, and asked them whenever circumstances allowed, 'Do you mind if I take your picture?' I caught a train to Bishop's Stortford and he met me at the station. It was a sunny spring day, and we had scarcely started talking when the *Sunday Times* rang up, telling him he was off to Pakistan next week to take a portrait of Mrs Bhutto. I couldn't help thinking his paper was spending a lot of McCullin's time and its own money on one mug-shot of a presidential widow which they could presumably obtain locally for a few pounds. Over lunch someone rang from Holland to tell him he was missing out on some great street demonstrations at the new queen's coronation. The message was 'come on in'. McCullin gave a shy laugh. He can do that. Like a lot of people who speak with great fluency about themselves, he has a lot to hide.

I wrote this in great haste in the train coming back and give it almost exactly as I wrote it:

There is tension just in shaking hands with him, it is a shy reach across a gulf, shy to the point of hostility. He has a rebel's eyes, dead clear under long eyelids, and a rebel's tenderness for his greater loves. He's a Slav somewhere, he has a strong wide brow and a boxer's lowered head. His stance as he comes at you is a little crablike. If he were in the ring, you would wonder whether he was a southpaw, but you would know at once that he punches with both hands. He is dreadfully vulnerable. His voice is not just flat, it's ironed out, so that the working-class Londoner's wrinkles have almost disappeared. Almost. He has a miner's shoulders and trunk, then the body tapers quickly. He's nimble and fit. The face from some angles is boyish, from others hollowed, weary and much too old, though the ageing is communicated less by lines than by shadow and pallor: the shadow of too much sensation, the pallor of too many lousy hotel rooms and lousy meals. His nose is broken, but it's an odd thing about noses that they mean nothing. Mouths, eyes, smiles, faces change, betray, communicate. But a nose doesn't change and doesn't mean anything, unless someone's hit it, or cut it up on the surgeon's table. He drives a Peugeot Estate, the Third World's

10

most reliable car, space for kids, cameras or wounded. Age scares him and he talks incessantly about his childhood. He's a very rich mixture indeed.

He talks incessantly, period, sometimes feeding me tailored quotes then looking at me sideways to see if I have registered them. He has a big, acquired vocabulary and a lot of verbal imagery. He seems to think I am unobservant: we go for a walk and he points out everything to me as we go along – the expended shotgun cartridge, the beauty of his self-made sanctuary so close to London, the amazing notion of commuting from it to far-flung places. He doesn't trust me to see *anything*, which is somehow very innocent and nice of him. He doesn't trust: he's wide open, waiting to be screwed.

He emphasises what an incredible existence he leads, the uncountable distances he has travelled, he hammers at the impossibility of encompassing so much of human life and staying 'one person, one anything'. To be photographing starving children one day and sitting down to supper with his own the next. I know all that already; in a small way I've done it myself, I've seen it in a lot of other people. But he doesn't trust me to see anything.

He loves the countryside with a townsman's passion, he loves it like a church which he has invested with all his prayers while he was away, but he photographs it with a funereal intensity, as a place that might lure him from his destiny, or have his body when he's dead. His love of family, of countryside, of the house he has converted – and vanquished at the expense of great physical effort – of his beautiful wife, have an almost desperate unity for him: one idyll, one pillow, one clean, intact, cherished body, one oasis from the red hells he visits constantly.

In Africa, he tells me – was it the Congo? – there was this bunch of white mercenaries who had one blue movie between them. When they had watched it for a while they would get hold of some black whores and bath them and squirt them with after-shave to remove their native smells before laying them.

At a French Foreign Legion fort where his brother was a corporal, four Algerian whores were brought in once a month to serve the entire unit. They used to hang four blankets as partitions for four camp beds, and the unit would queue up to take its turn. McCullin's brother bolted and the girl asked him whether he was queer.

He shows me a photograph of a Vietnamese boy with whose corpse he unknowingly kept company for days: the body was the other side of a corrugated iron sheet. The photograph shows the contents of the boy's pockets turned out in the mud, and this dead, beautiful companion in permanent sleep. If it were a painting, I would call it sentimental; but it isn't, it's life, and it's love outraged, it's a cry of fury from deep inside McCullin's feeling heart, but I think he wants me to understand that it's also a

11

cry of fury about his own truncated childhood. I do, but the strength of the picture is that it makes me care a great deal more about the boy than about the lonely devil of a photographer who had to share a foxhole with his corpse. (Had McCullin turned out the pockets himself? I asked him later. No, he never would, the American soldiers had already plundered the boy.)

His photographs of England – *Homecoming* – are war pictures taken in peacetime, I remember. He's making a battlefield wherever he goes. Is that what burns him? Does he secretly believe he is the author of the misfortunes that obsess him?

More photographs from red hells. Behind us in the glass-fronted cupboard I notice a collection of antique toys, very pretty, quite valuable. 'Bought the lot for a couple of quid a few years ago,' he says. For himself, apparently. For his own unlived childhood. Not for his kids.

He also began a collection of old children's books – but that was ten years ago. The puritan again: he has to tell me what he paid for them so that I don't think he throws away his money. His father, he tells me incidentally, encouraged him to draw, died at forty, horribly. He talks all the time, on and on, partly in self-protection because he is so shy, partly to be helpful because I am a fellow performer. He seems at first to have no curiosity about me at all, yet he is very gentle, very concerned to know how he can best provide for me. I suspect that his intellect is visual, and the lens has been on me long enough. You can only photograph someone for so long.

As with most journalists his highs and lows follow each other very fast. He goes slack for a bit, then bounces back with more words; words to fill the silence. I have the feeling he has difficulty in reviving his interest in me.

McCullin boy and man have both taken a hell of a lot of hidings, he would have me know – though I know it already from his printed text – at school, from bully-boys and mindless, violent staff. The man – if there is a difference in him, in me, in any of us between boy and man – has been wounded in ambush by the Khmer Rouge and worked over in prison with sticks, fists and boots by Amin's soldiers. He is defiant about being able to take punishment and it crosses my mind that, in a rather fearsome, T. E. Lawrence sort of way, the flails of punishment have sometimes eased his conscience. I think of *Candide*: he does not know how innocent he is of the crimes of which he constantly accuses himself.

Air travel too is a punishment for him, a non-stop sensory deprivation which leaves him manic, he says. It does me too. He recalls landing in Saigon in that state and getting the treatment from the white mice – which was the correspondents' expression for the Saigon police. In the same breath he tells me how he stole coal as a kid and had

to brave the dangerous places where the weirdos hung out; about his father's gambling on the dogs, and his lingering, awful death. One day, he intends to check out his genealogy and discover where he really came from. He has taken a first step but goofed and went to the wrong place.

I can't get a question in edgeways. He is talking so much that I find myself wondering whether he is really suffering from a kind of permanent jet-lag, and I am just another stranger in the next-door plane seat. I notice the glaze in his eyes, and suspect he is tired of my presence; that I am already the subject he has photographed, who insists on sticking around.

He even sits as if he were flying, in neat, nervous containment, with his hands wedged in the crevices of his body – one under his knee, the other in his armpit. I can't remember anyone who crammed so much intensity into sitting still.

I ask to see more pictures. Relieved by the call to action he leaps to his feet. Photography is *not an art*, he insists, feeding me more quotes, it is *applied science*. I have read about this in his text to *Homecoming* but he doesn't trust me to remember things, nor – which is a little terrifying in someone four years younger than I am – nor does he quite remember what he has told me an hour before. Or perhaps, because he doesn't trust me and I take no notes, he feels he should repeat it.

Photography is the employment of a scientific discovery related to emulsion and the speed of light, he says. He disowns all technical knowledge: did they not fail him in his photography test in the Air Force? (He's still angry about that, I notice, and funnily enough so would I be, so I like him for it.) Well, he says proudly, they would fail him again tomorrow. At this point I would quite like to ask him: 'All right it's not an art. But all the same do you see *yourself* as an *artist*?'

But I am beginning to learn that we are not ready to have dialogues about such things; his answers would be too swift, too ready. Later maybe. The question is also unfair because McCullin has to live with his fellow journalists, and they're not a forgiving bunch when they sniff pretension. As to myself, I have no doubt what he is; I knew before I ever got on the train, and in this sense his own opinion of himself is irrelevant. He is an artist, and hard luck to him. That's something he must live with in his own way.

There are chickens in the garden and he is reclaiming an old barnyard, making ground, his ground. The chicken mess worries him, though; it conflicts with his fastidious requirements. He is also worried about the projected new airport at Stansted. Maybe they'll have to find a new idyll somewhere else.

He is talking about courage and suggesting it is only the blanket that covers terror.

He is talking, as any artist will, obsessively about himself – not with vanity, himself as a phenomenon. If I told him I had camped in a mortuary for a year or had had a heart transplant he would give a polite acknowledgement and continue with his narrative. It's *his* life that matters, and I can understand that too. It's *his* bombarded pendulum life between the Inferno and the Savoy Hotel that he contemplates with his tender rebel's eyes. It's *his* life that fascinates him, *his* life, very properly, that sets him marvelling at the whole human race. And he tells me photography is not an art?

He can still do it, he tells me, talking about battle. He can still face it, out there in the middle, still relish it and keep his head, but for how much longer? He shows me a picture in which a U.S. Marine is yelling at him not to be a silly bastard and get his arse down. A Marine, from the cover of a building, tells him to take cover . . . He does not say so, but daring and winning are inseparable in his mind.

He talks about fate the way a racing driver does, or a combat soldier. One day, your number will come up. One day, they'll deal you the bad card. Then he'll join his father, for whose pride and good name he strives. I do not know whether McCullin believes in God the Father, but his own father certainly has a touch of divinity for him.

Fear again. He has known all forms of fear, he says, he's an expert in it. He has come back from God knows how many brinks, all different. His experience in a Ugandan prison alone, which he relates to me, would be enough to unhinge another man – like myself, as a matter of fact – for good. He has been forfeit more times than he can remember, he says. But he is not bragging, he is explaining, and anyway my information about that part of him is way out in front of anything he has so far told me – but of that, more later. Talking this way about death and risk, he seems to be implying quite consciously that by testing his luck each time, he is testing his Maker's indulgence. To survive is to be condoned and blessed again. To perish is the reward of his repeated hubris. My own father, who loved to gamble, got the same kicks out of risking everything he had. But McCullin, when I asked him, doesn't gamble, it leaves him completely cold. He's careful about whatever reward he gets, he conserves gratefully, and with a sort of wonder. Nobody is ever going to put him back where he came from. As a matter of fact, the same goes for me, yet again.

From courage we pass to age. *His* age. We have touched on it very early on, but now we go back to it. We are walking, patrolling his idyll, and I notice that the screws are slipping on his London accent and it is beginning to show, which suggests to me that he is tired again: not physically tired, but tired of the exposure, tired of me, tired of all the talk and no action.

Our walk takes us an hour and a quarter and he asks me no fewer than three times in the course of it, rather quaintly, whether I am 'overtaxed'. His concern for me is physical, not financial. He really is very shy. I tell him that I normally walk a couple of hours a day but I don't think this sinks in. Then the eye-opener: he has never walked this far in his own countryside before.

Will middle-age exhaust his courage? he wonders. He has tufts of grey in his sideburns and at the back of his neck to illustrate his concern. He believes in driving himself hard, he explains; that way you stay fit. 'Fitness is my survival. If you walk with soldiers twenty years your junior, you've got to be able to survive them. In Hué I was lying up at the front with some soldiers. Their officer was dead and I was thirty-three. I suddenly realised they were looking to me as their leader. You've got to be ready to take the responsibility.' Even when he took on a derelict house, he worked himself to exhaustion. He is concerned lest he lose his *appeal* to the people he photographs, he says.

This is my second eye-opener and this time it's pure magic:

McCullin is talking of the elusive moment of connection with his subject – the '*yes*'. The moment of naked affinity, when he or she sees him, and forgives him, at death's edge, starving, inconsolably bereaved, when their own child lies dead on the hall floor, bombed in the attack: still '*yes*'. Yes, take me. Yes, take us. Yes, show the world my pain. And I remember reading or hearing somewhere that an ailing buck has been seen to hang back from the herd, and to turn and face his predator with acceptance: '*yes*'.

Anyway, that revelation alone is three-star Michelin, worth the whole journey.

Death again. He has lost a lot of friends and is loyal to their memory but he doesn't like bullshit. He honours the dead a lot and one reason why he can't warm to the Vietnamese is that once when he was battle-weary he saw a Vietnamese soldier urinating near the head of the body of his dead comrade.

My early questions of him about technique had led nowhere, partly because I don't know enough to be wise, partly because he wishes me to know that the camera is his unconscious extension, he doesn't think of it. But now I remember seeing war-photographers in Phnom Penh, usually Cambodian boys on a couple of dollars a day, with their cameras taped with sticking plaster on fixed settings, so that in the heat of battle all they had to do was click away for as long as they stayed alive, which was the variable part of the operation. Do you set up the camera every time, I ask, in every situation? Yes, he absolutely does. A vehement affirmative. He has *never* taken a picture without first taking a light reading.

Christ, I thought, remembering some of those photographs. Thinking of Hué and Khe Sanh and the Tet offensive and the other impenetrable hells where I have not been, but where everything I have heard tells me there is no incentive to take any kind of reading whatever; where the only serious incentive was to hold your balls and pray and stay alive.

If he's going to die taking a picture, it'll be for something worth having, he explains. And I have a sense that he owes it to himself, to his destiny, to his father, to his childhood, to the conscience that day and night seems to hammer at his door, to live hard and die well, striving for the best. For that's another thing that drives him, that's why he talks about age and retirement and doing other things: the fear that he will flag in his quest for excellence, and let his father down.

Food is more of a worry to him than drink in this respect, he tells me. A shot of brandy quells the rising terror faster than anything; he has tried them all. But what if the night could come when he cannot bed down on the rocks with Afghan tribesmen without craving for a bite of Western food? To ward off these unseemly pangs he takes instant porridge with him: another three-star Michelin admission.

By now we have inspected his darkroom – he tells me I am the first to have been so honoured and I believe him – we have looked at the hells of war and a few of the hells of peace – evocations of his own miserable childhood which, like others who have had a similar crippling experience, he yearns for with a paradoxical nostalgia, just as he has a nostalgia for the tensions and privations of the battlefield, where by all accounts he is both unique and self-effacing.

He tells me for the third time now that there is a side of him that actually finds war addictive, as if I ever doubted it, or hadn't heard, because for a while now I had been thinking of the line in Michael Herr's *Dispatches*: '*I think that Vietnam was what we had instead of happy childhoods.*' And of Graham Greene's aphorism that childhood is the credit balance of the novelist. And of the bought toys in the glass-fronted cupboard, and of the old children's books from someone else's childhood, and of a lot of other connections he was still somehow too restless, too remote, to be able to hear. And I was secretly annoyed with myself that I had cheaply presumed, earlier in our conversation, to equate my own treasured childhood miseries with his, because his are a hundred, a thousand times worse than mine ever were, though, like mine, they gave him motive, and the hardening.

We have looked at some beautiful photographs of English countryside shot like the fitful dreams he must have had in foxholes while he dozed beside that dead Vietnamese

16

boy. His son comes back from school. His beautiful, fair wife has come back from the town. It's a sunny English evening in the spring, and the pretty, sheer kitchen is the fruit of his hard labour. Suddenly it's time for me to go – whether I have had enough I don't know, but McCullin certainly has. There are trains every few minutes but he has got one in mind for me, or says he has, a fast one – raincoat, briefcase, quick into the Third-World Peugeot and he drives me fast and well to the station. 'I like to make quick departures,' he explains, and I forbear to tell him that it's my departure and not his. 'Next time you must do more of the talking,' he tells me, with a resurgence of his shyness. 'It kind of gives a framework.' Yes, I told him, next time I would like to take down a *curriculum vitae* with dates and places.

There are two trains, a fast one and a slow one. When he is safely out of sight I transfer myself to the slow one to give myself time to write, for I want to develop my pictures of him while the original is still fresh in my mind. It's a long time – or I hope it is – since anyone was quite so glad to see me go. We shall meet on Tuesday, three days hence. On Monday, with his knowledge, I propose to talk to people he has worked with. Meanwhile there is one parting line he spoke that haunts me more than any that he thoughtfully offered me for quotation. 'Maybe you could tell me where I'm at,' he said, shortly before we parted company, to that passenger in the jet-aeroplane seat beside him. 'Whether my life is just beginning. Or whether it's over.'

I paid a price for my zeal, incidentally. When I transferred trains I left my raincoat behind, so it must have gone to Liverpool Street without me inside it.

Next morning, reading through what I had written, I found to my surprise that it was not Don McCullin whom I found a little hard to take, but myself. McCullin had himself straight, but at what cost. He was a communicator of the world's worst agonies, a pilgrim to the front line of human suffering, returning with his kit-bag of horrors to appal the comfortable, the wilfully blind and the unknowing. At times, visiting his hells, he had been a sharer. When had I? It was myself, not he, who was being evasive. It was myself, not he, who was finding methods of wriggling away from the starkness of his experience. The night's sleep had also reminded me of my own feelings about being interviewed: how, long ago, I had set up defences which today only the stray shot penetrates. How I developed my stock responses to recurring bloody silly questions from even sillier people, a whole handful of bland and seemingly confessive phrases to fill their notebooks. For my own protection.

So why should I feel cheated, now that I have elected to turn interviewer for once, if McCullin does the same to me? He can do nothing lazily, nothing that does not

touch upon the enigma of existence. In a grey, confused, elusive, ever-compromising world, he has the gall to think of life and death and the purpose of existence.

H. D. S. Greenway covered the Vietnam and Cambodian wars first for *Time* Magazine, then for the *Washington Post*. He was one of the most respected and intrepid of the war reporters, and certainly one of the most experienced. He was recently decorated for gallantry by the U.S. Marines, together with one other journalist, having been wounded at the battle of Hué. He now has an editorial appointment with the *Boston Globe*. I rang him on Monday:

'McCullin was simply out on his own among the photographers. The Sean Flynns and their kind were too flakey for him, too flamboyant, too uncomfortable for this puritanical, shy, introspective, English working-class boy. Don played right in on the horns, like a great bullfighter. In the awful battle of Hué in February '68 there was a forward position where a Marine company had taken a lot of casualties, all among the muddle of these eighteenth-century walls. Anyway there was this agony about whether they could get relief up with so much firing going on, and they couldn't. Later the company commander asked me: "Do you know McCullin?" Well, yes I do. "Well this guy McCullin went up and got them out all on his own." The commander wouldn't even have sent up a corporal. "If McCullin were in the Marines I'd put him in for a Navy Cross," he said. That's the second highest decoration for valour . . . Oh, and get him to tell you that time he was hit with shrapnel in Cambodia and he was too terrified to look inside his pants . . .'

Later, when I followed Greenway's advice, McCullin gave me this story:

His ear was burst, both his legs were filled with mortar shrapnel, which is red hot when it hits the body. There was blood coming out of his fly. In the end he rolled down a river bank and pulled his trousers down. He was hit in the groin, but by a mercy not in the places men most dread.

Waiting for Tuesday, I went back to his photographs, and his confessions:

'When I was younger I did it to become famous,' McCullin says in his introduction to *Homecoming*.

And of his childhood: 'I learned how to stand with my jacket off and fight other boys. That was the only way you could get respect from the pack.'

And again of his childhood: 'Everyone seemed to have singled me out to be knocked about.'

And of his father: 'My fear was his dying [of chronic asthma]. My strength was in trying to play a part in his survival.' At night he stole coal. Repeatedly, he would have us understand his empathy with those who suffer: 'I've been there,' he writes.

William Shawcross is a journalist and the author of the much-acclaimed book *Sideshow*, which tells the inside story of the Cambodian bombings:

'I knew Don best in the 1972 offensive in Vietnam. He was a frightening person to work with because he took such mad risks. Perhaps as a photographer he felt he had to. Perhaps as a journalist I should have felt the same. We went some of the way up Route 13 together, then Don just kept going. I didn't. It was frightful where he went but he still kept going. The best thing about him was his gentleness. Most of us in the Third World get inured to poverty. Don never did. We'd be having breakfast in the Royal in Saigon and he'd see a kid out in the street, not soliciting or anything, and he'd just grab a loaf of bread and take it out to him.'

Still waiting for Tuesday:

I think that McCullin was peace-weary before he ever went to war. He arrived at the battlefield with open wounds and he has bitterly refused ever since to let them heal. He is an incurably earnest person without protection from the world he has confided in. But then being unprotected is his theme. Sartre in *La Chambre* has a woman observing her husband's delirium and longing to enter his secret universe, where she would like to sleep with the door closed for ever. The image fascinated Camus, himself no stranger to human pain. The dead and nearly dead, like the mad, are free, but their freedom is no use to them. I expect that McCullin has committed suicide through his camera many times, only to lower the viewfinder and discover himself once again sane, and intact, and obliged to continue 'a normal life'. Part of what he calls his 'guilt', perhaps, is his ability to be effective in an unnavigable world: to remain alive among the dying. Seen this way, McCullin the war photographer is, after all, McCullin the photographer of landscape: he is the same ghostly sentinel, haunting the gardens where he wants to live.

If it is possible – as Camus insists that it is – 'to feel, without romanticism, nostalgia for lost poverty', then perhaps it is also possible to feel nostalgia for physical suffering as a form of human nobility from which our good luck too frequently withholds us.

For most writers, and certainly for most photographers, the reality of suffering is incommunicable. There are several reasons for this, mostly to do with our own sloth

and cowardice as an audience. We sit in our armchairs, like television viewers staring at sequences of battle, we have a whole armoury of mental mechanisms designed to spare us anything more than momentary, glancing involvement. Nor is the war photographer himself, or the writer dabbling in 'reality', so very different. He too has his mechanisms, his arms-length procedures for gazing upon the agony of others. I could even wonder whether this is the secret frustration of torturers. They see pain, they inflict it, they study diligently to increase it. Yet by cutting off whatever streams of sympathy they possess, they deprive themselves of the very insights which would enable them to excel in their vile profession.

But McCullin has bridged the gap. There is a part of me that would rather watch any amount of television footage of battle than be forced to leaf through McCullin's albums of human suffering. His refusal to let distance intervene; his refusal to switch off, to compromise in any way in the relationship between himself and his subject; his urgent, vehement scream to us of 'LOOK!' – they rob us of our armoury, our blinkers, our complacency, they bring us out of our armchairs. To his own question about the aim of all his endeavour, Joseph Conrad replied '. . . to make you hear, to make you feel, it is before all to make you *see*.'

Yes, that will do nicely for McCullin.

Harold Evans is the Editor of the *Sunday Times* and accordingly Don McCullin's employer. He has already written about McCullin the photographer in his indispensable *vade-mecum* for photo-journalists and editors, *Pictures on a Page*. I asked him for an impression of McCullin the man:

'Don McCullin's courage is clearly testified to by his photographic images, but in reality never more eloquently than when Nicholas Tomalin was blown up in his car in No Man's Land between the Israeli and Syrian forces during the Yom Kippur war. As soon as he heard what had happened, McCullin raced down to Tomalin's car, ignoring the warning of Israeli officers, right into the middle of a rocket and rifle area. Having identified the body, he picked up Tomalin's spectacles and ran back to his colleagues and relative safety. Like many brave men, he was terrified. He had dried up completely. When he got back he couldn't speak for minutes. Yet at the end of the day, while we must honour his valour, we must also appreciate his extraordinary talent for photographic composition. Anyway that's what I want to say. Work it around however you like.'

He sounded suddenly embarrassed, as if he felt he had been callous in some way that he had not. I tried working it around as he asked, but I couldn't come up with

anything better, so I let it stand as an awkward moment: '*Yes, he'd brave a lion, but look at the way he composes his photographs . . .*'

Tuesday has come and gone, so has McCullin. But the battle between us was somehow over, there was just a little mopping up to be done. I had been nursing plans to break down his life into dates and places, to show a factual progression of the man which might usefully be reflected in a chronological arrangement of the photographs. I had thought, rather like a policeman, that by pinning him to a mundane narration of facts, I might unearth some clue to him which he was unconsciously concealing. Instead we went for a walk on Hampstead Heath in the continuing heat wave. We had not gone fifty yards before he let out a little cry of dismay and pointed behind us, to a patch of ground we had just traversed. A fledgling – a starling, probably – no bigger than a matchbox, had fallen from its nest and lay dead, spreadeagled on the gravel. Had I seen it? he asked. Well no, damn it, as a matter of fact I hadn't.

 He leaves for Pakistan on Friday.

Except that he didn't. Like many journalistic assignments, this one was dumped at the last minute for reasons I didn't quite listen to when he telephoned. I wanted to know his verdict. Yes, he had read my piece. No, he had no objections to it, he even cared for it, he'd be consulting his plastic surgeon about altering his appearance to suit my description of him. Just a few 't's to cross, so we crossed them. And the rest? I asked. No, no, he liked it. No, he really did. He just hoped people wouldn't think he lacked a sense of humour. This really threw me, but for completeness' sake I'll try. Yes, indeed: Don McCullin has a sense of humour. It comes as a bubbly, confiding laugh, dispelling introspection, half way to self-parody.

 If I led his life I'd need it very badly.

<div align="right">John le Carré</div>

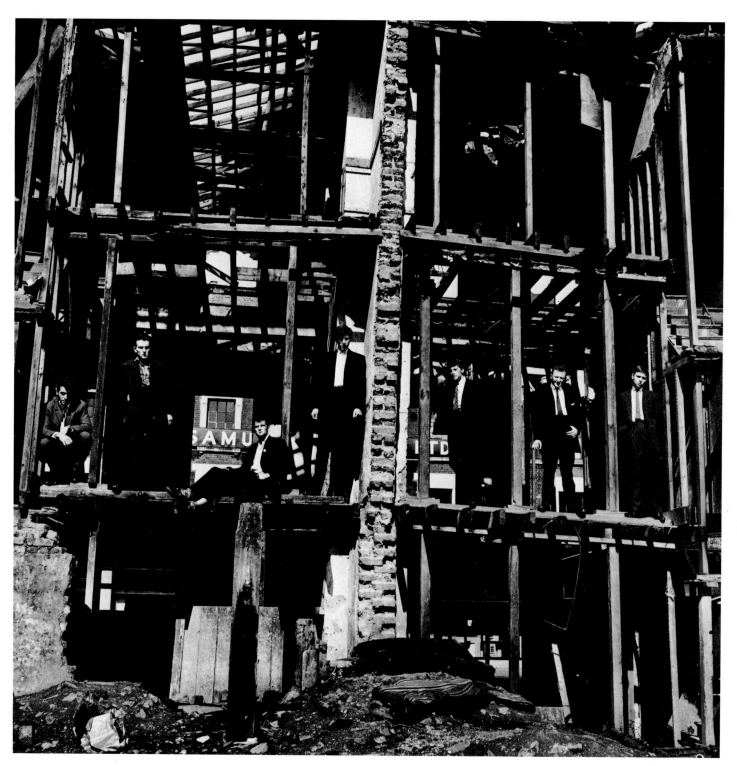

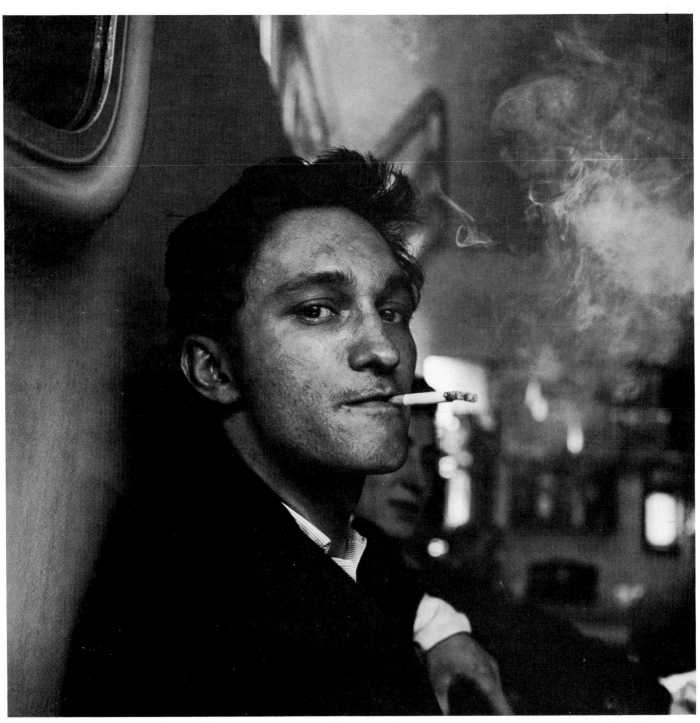

2 1958

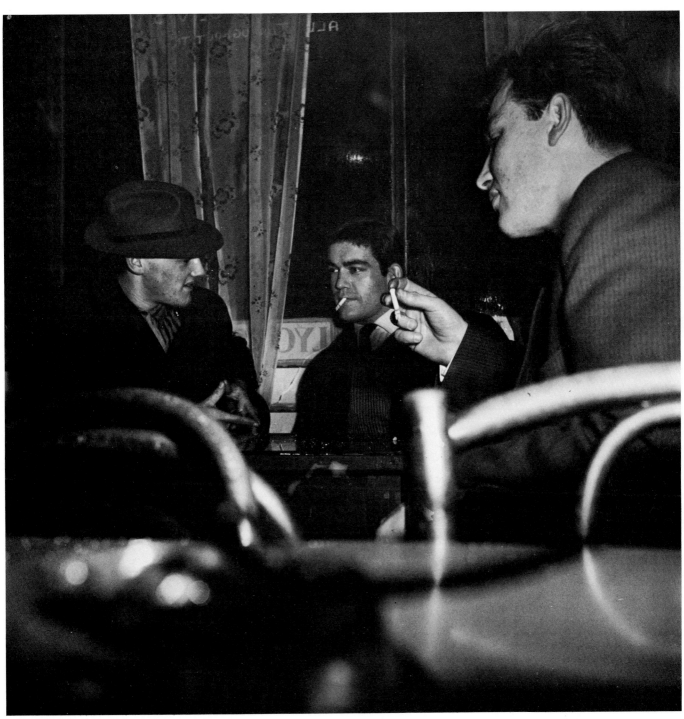

1958 3

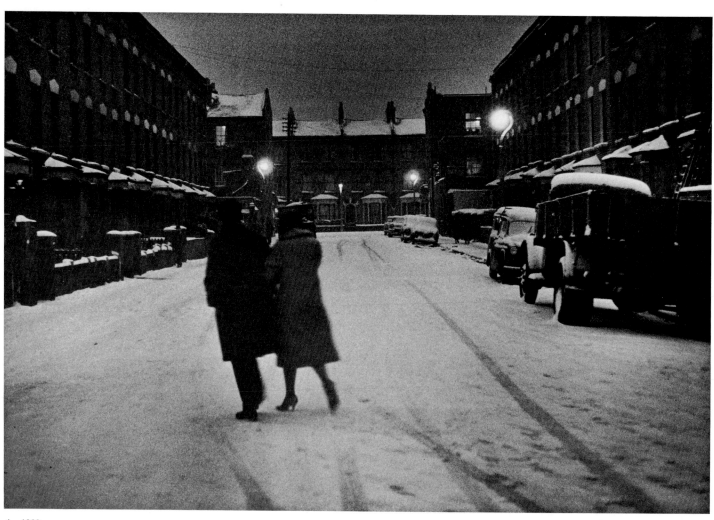

4 1963

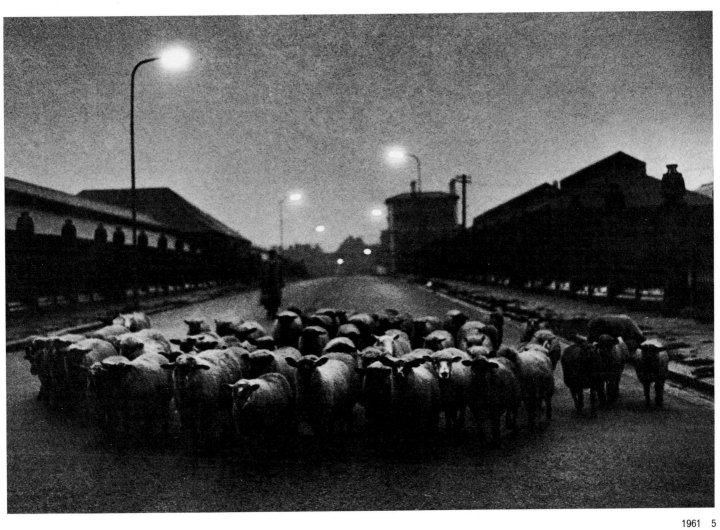

1961 5

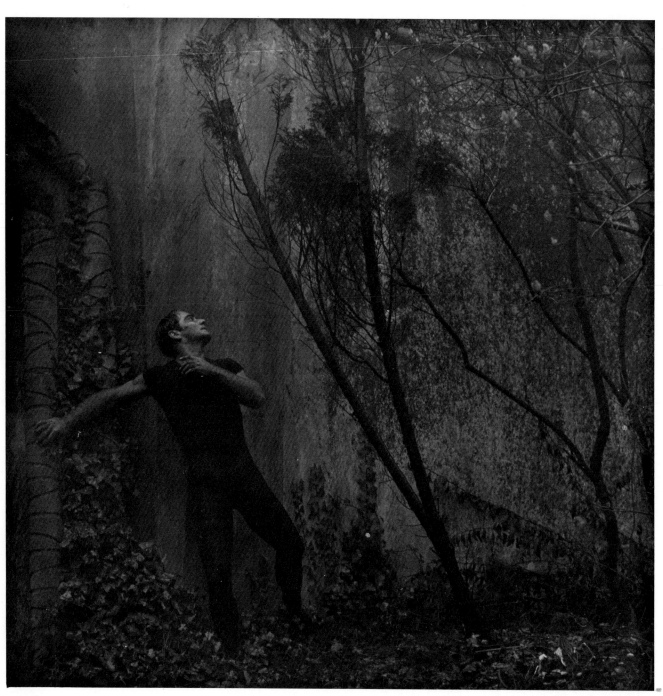

6 1959

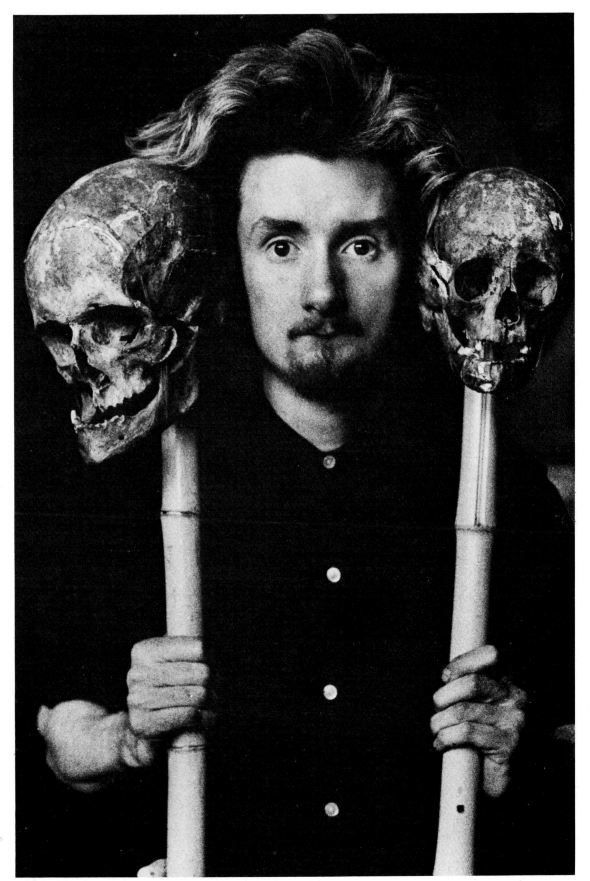

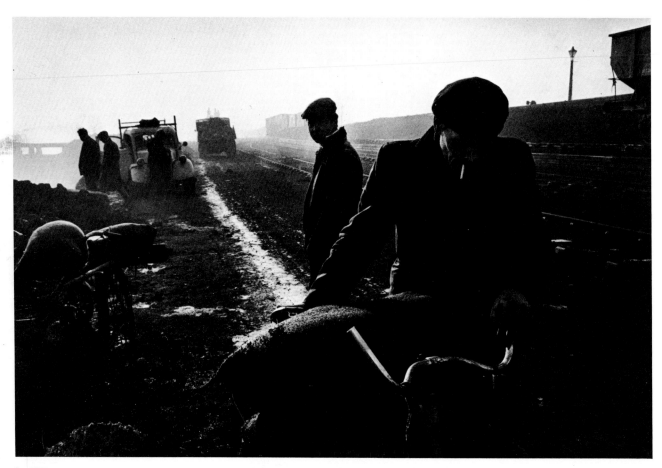

8 1963

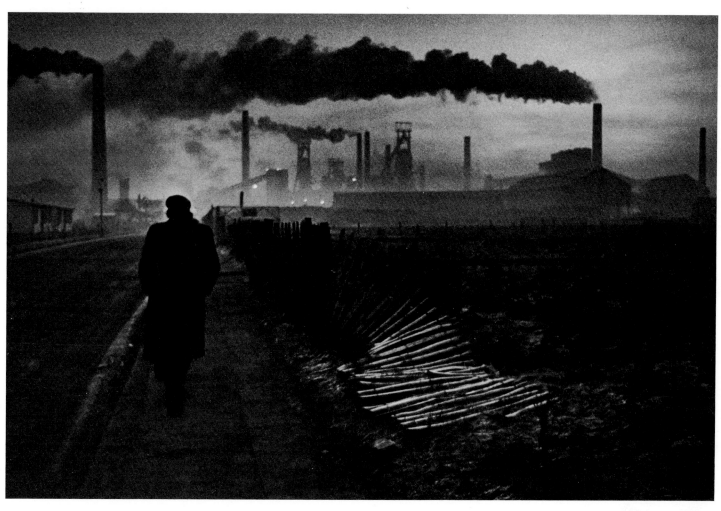

1963 9

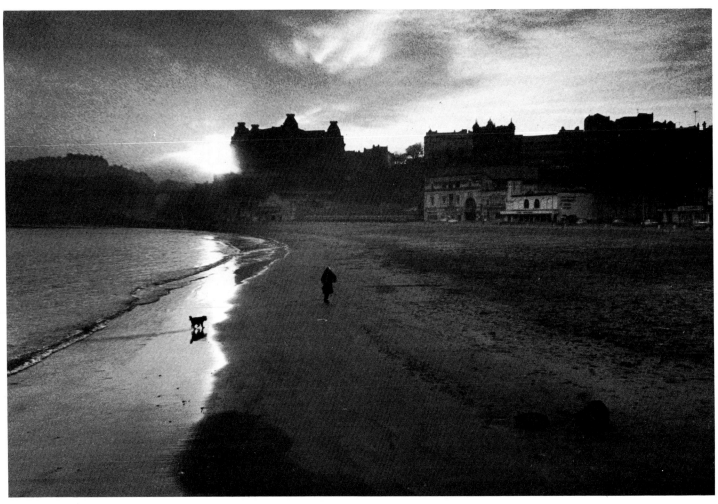

10 1967

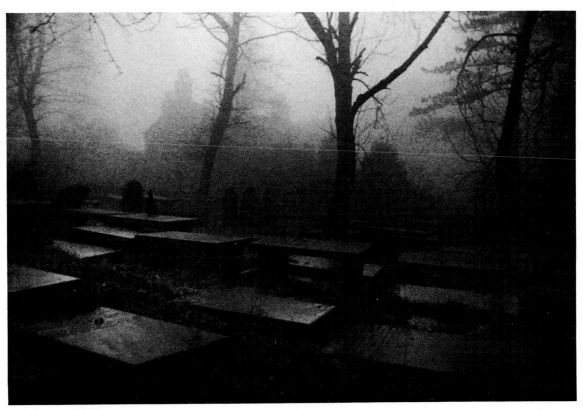

1967 11

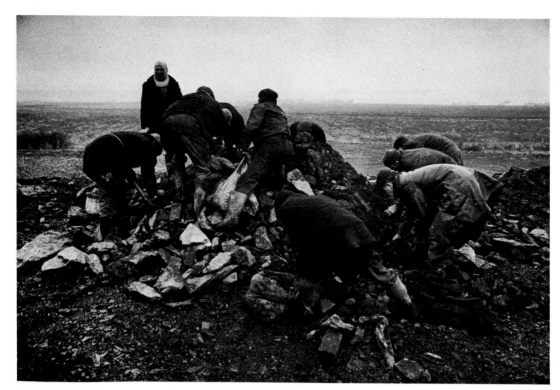

12 1964

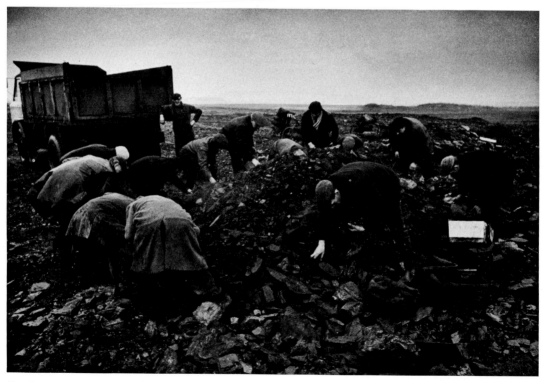

13 1964

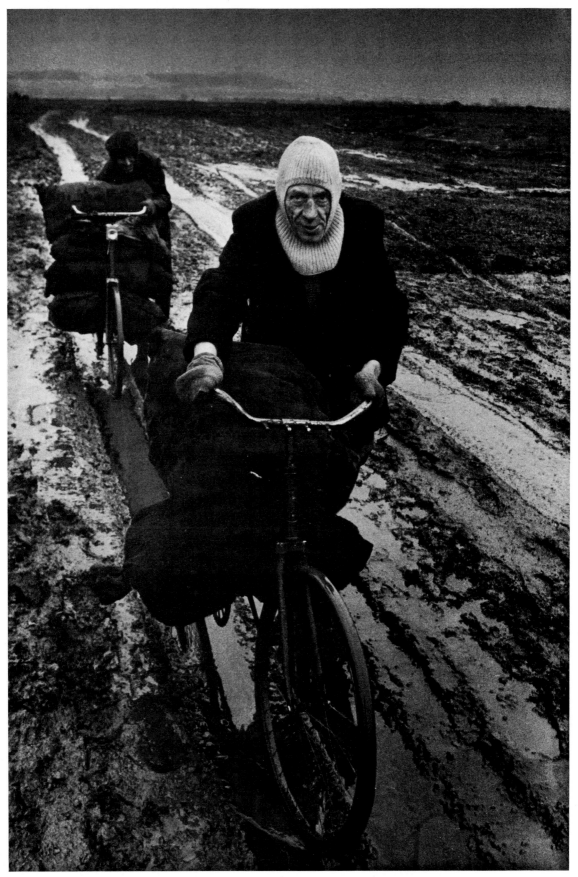

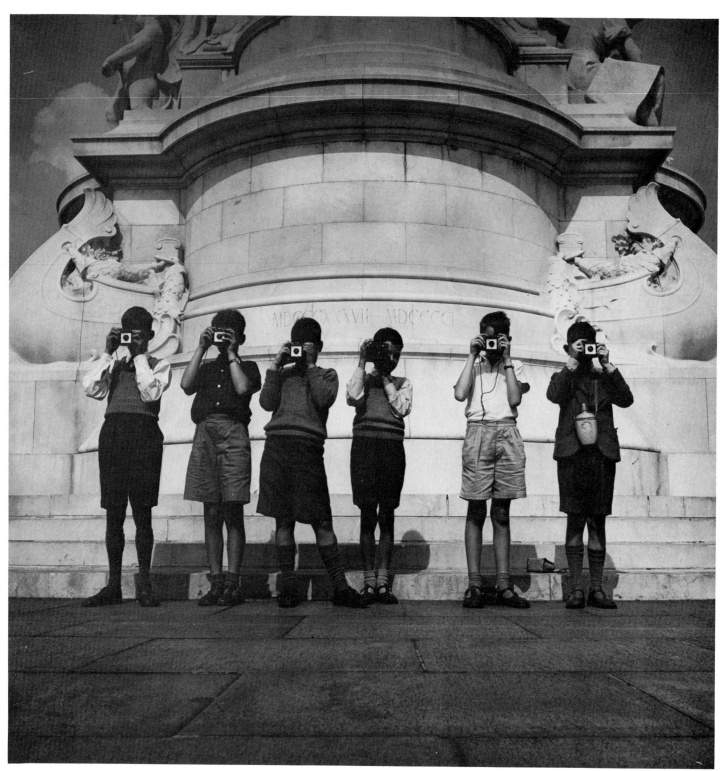

15 1960

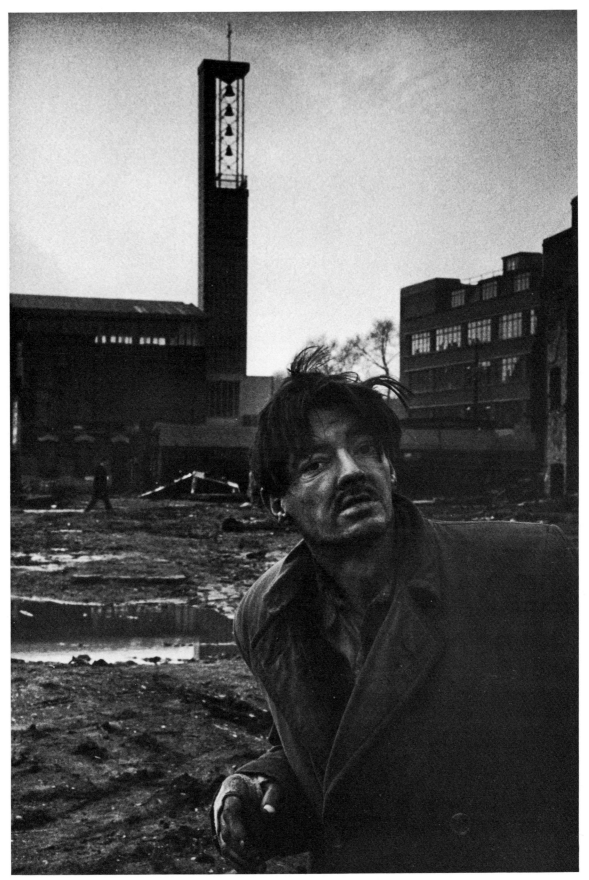

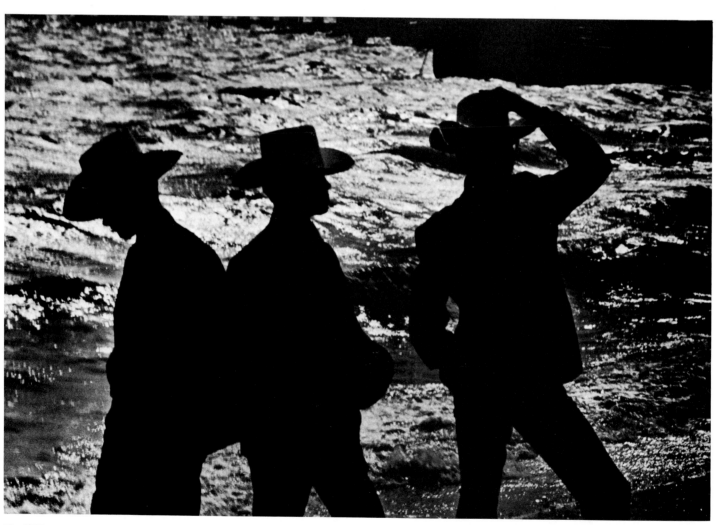

17 1965

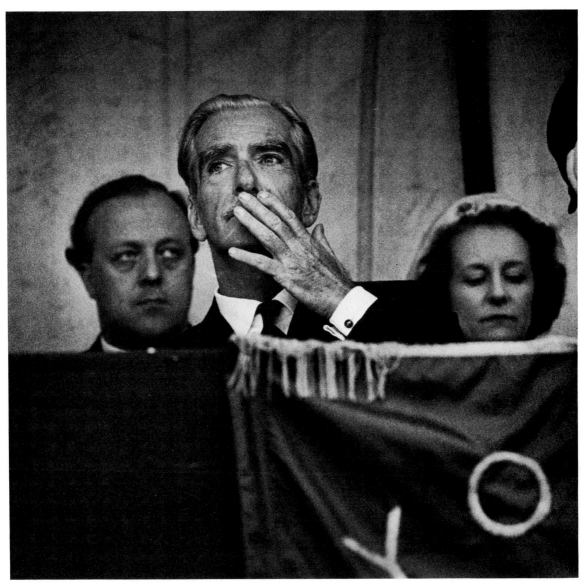

1964 18

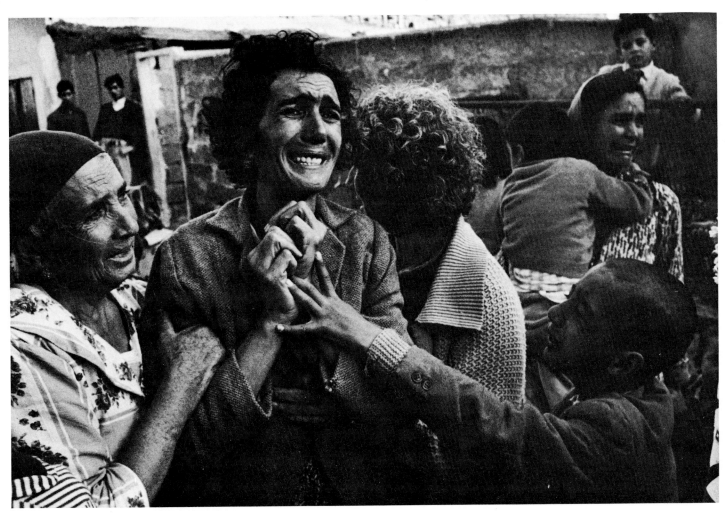

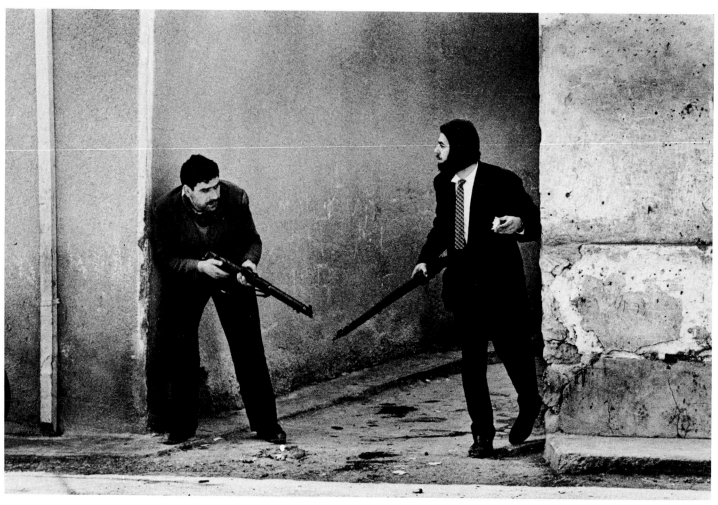

20 1964

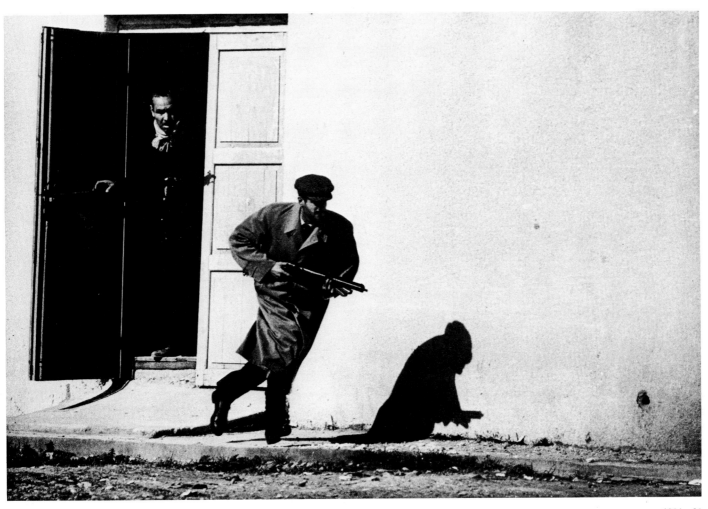

1964 21

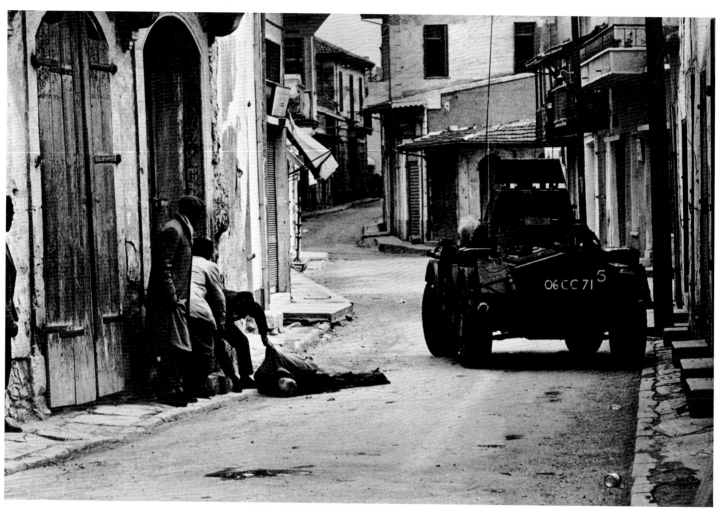

22 1964

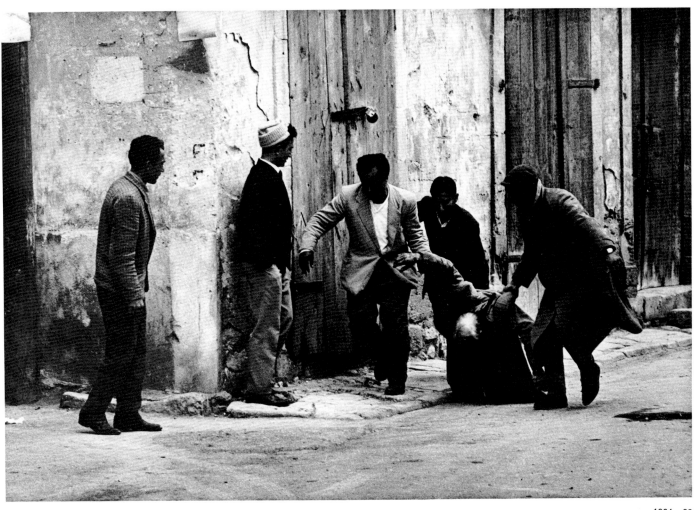

1964　23

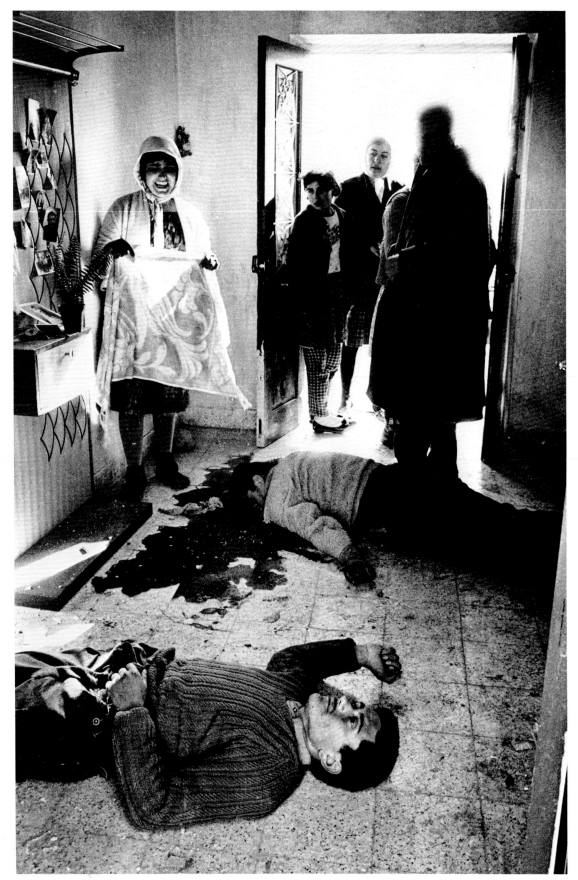

24 1964

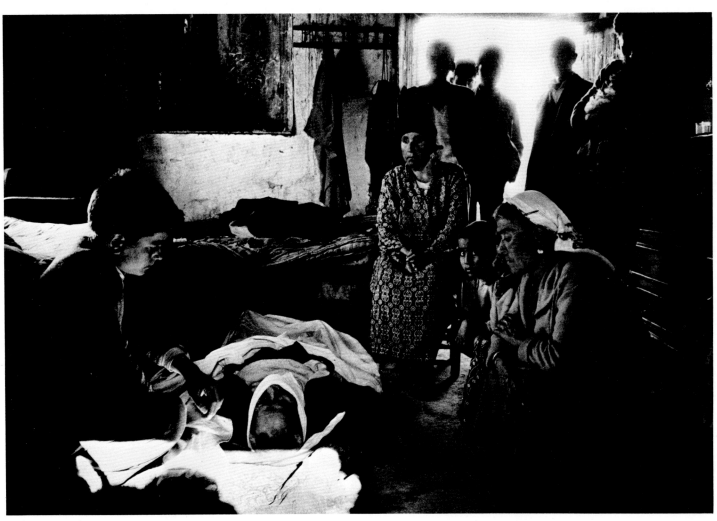

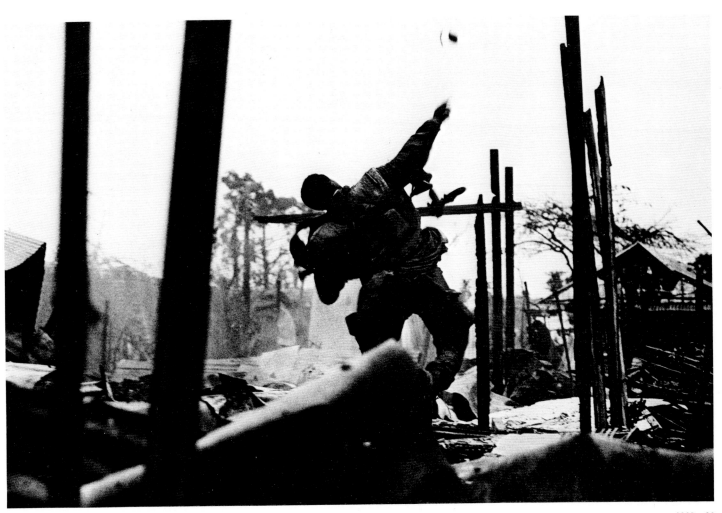

1968 26

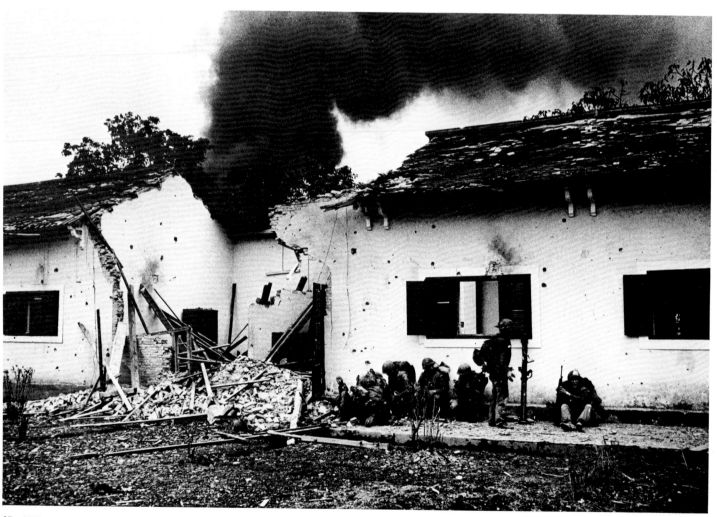

27 1968

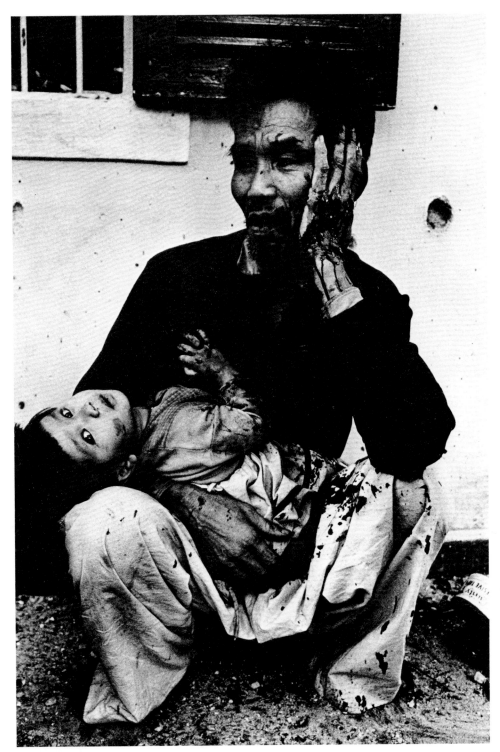

1968 28

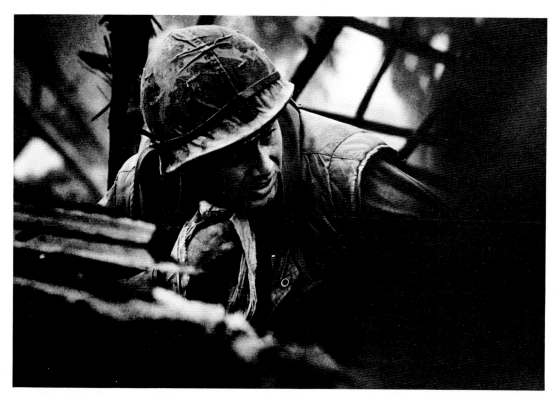

29 1968

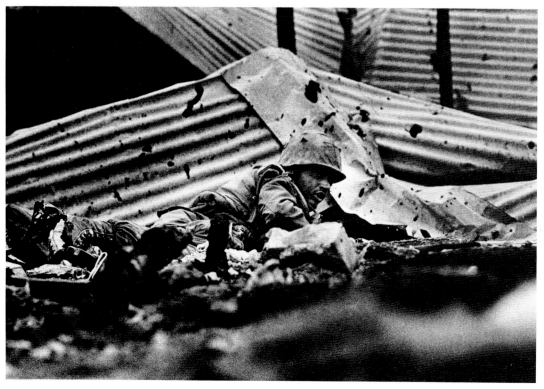

30 1968

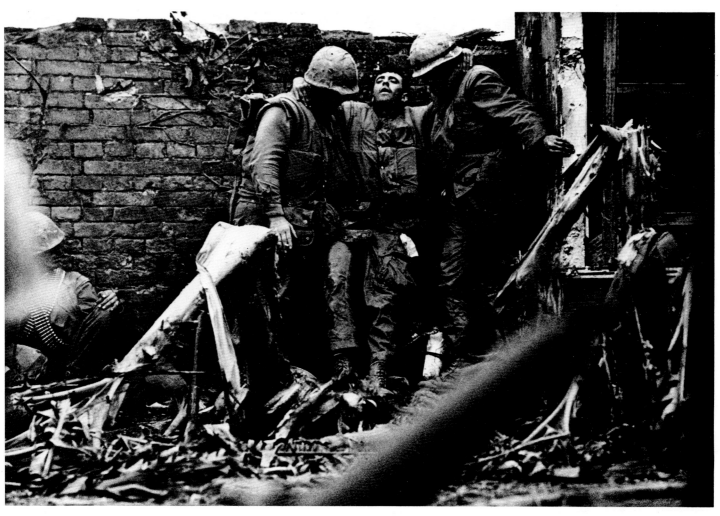

1968 31

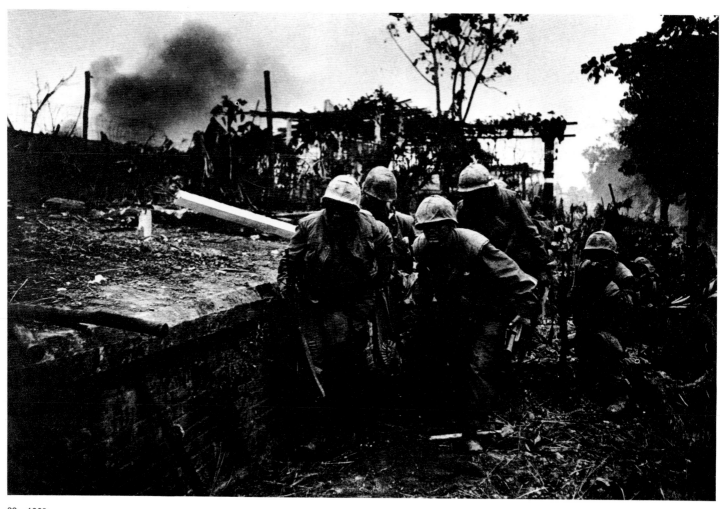

32 1968

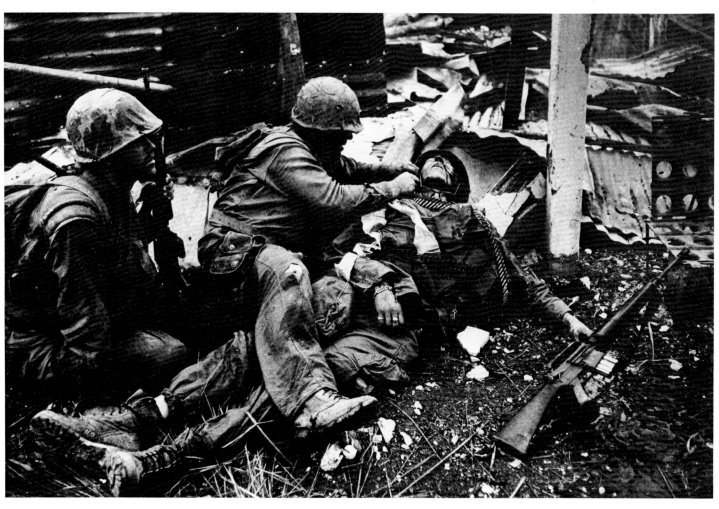

1968 33

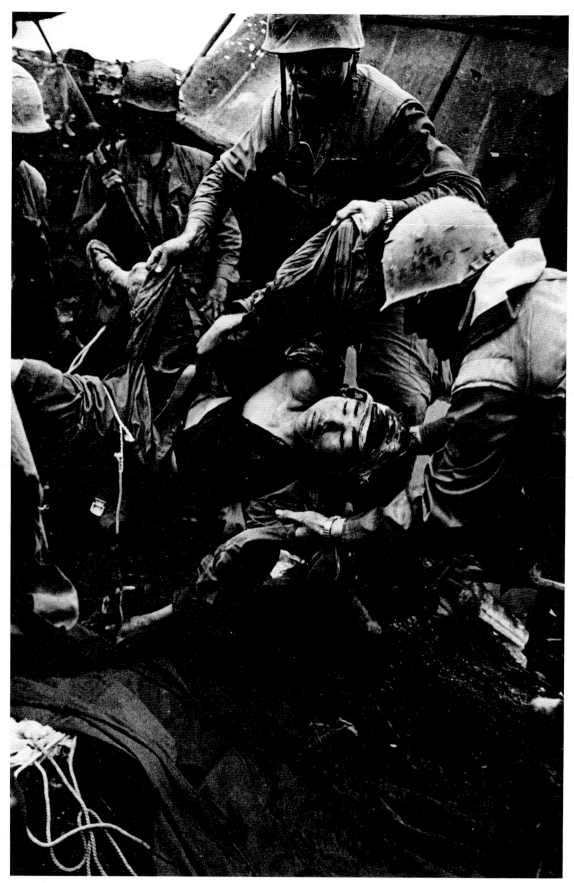

34 1968

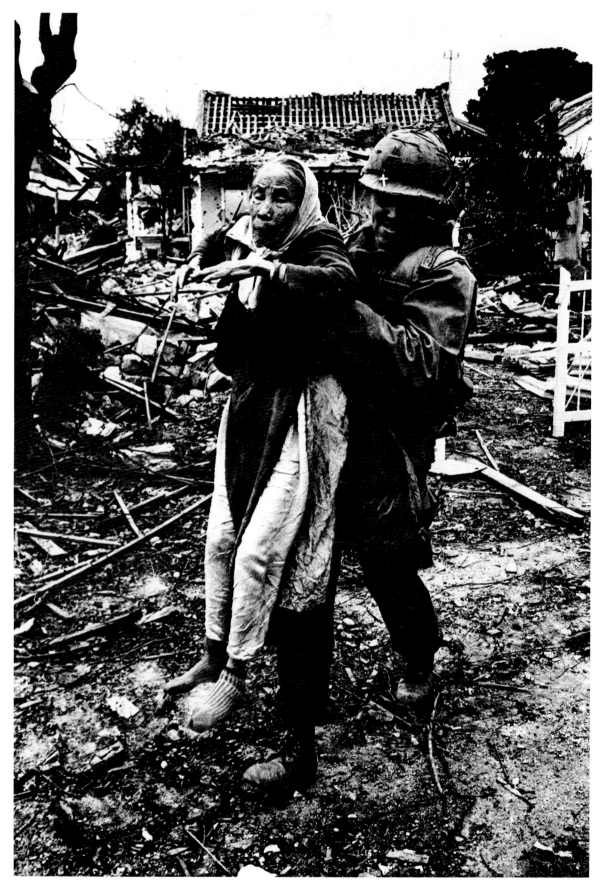

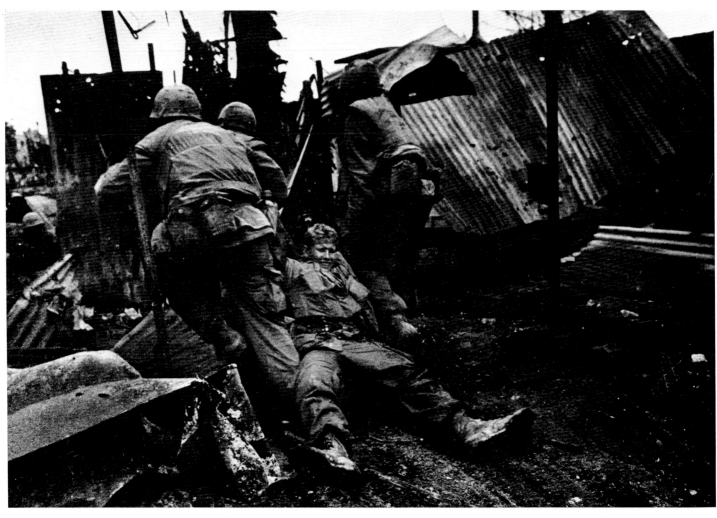

36 1968

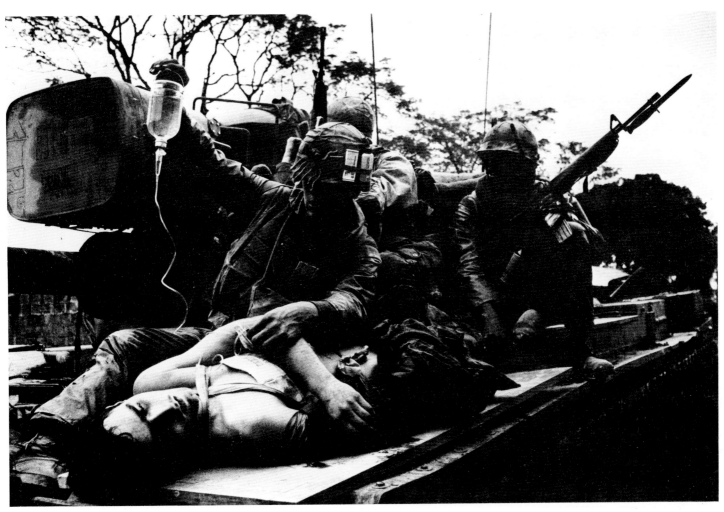

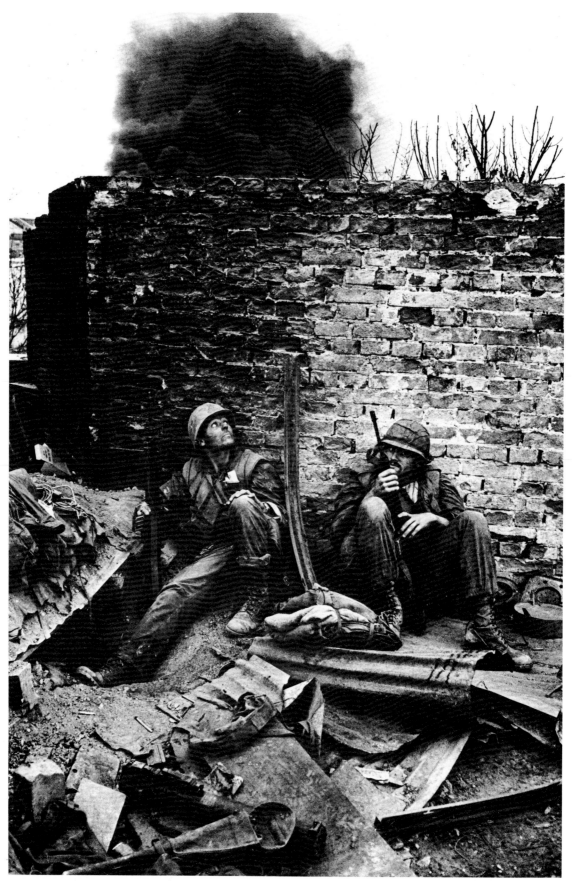

38 1968

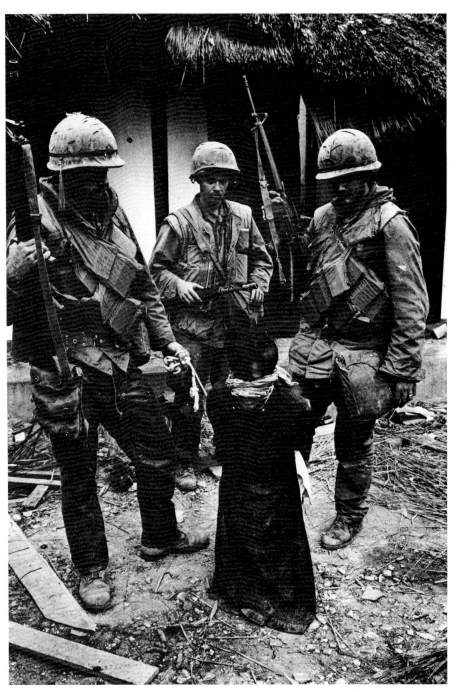

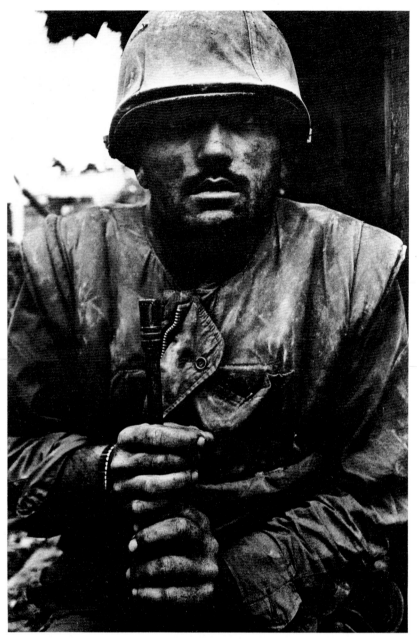

40 1968

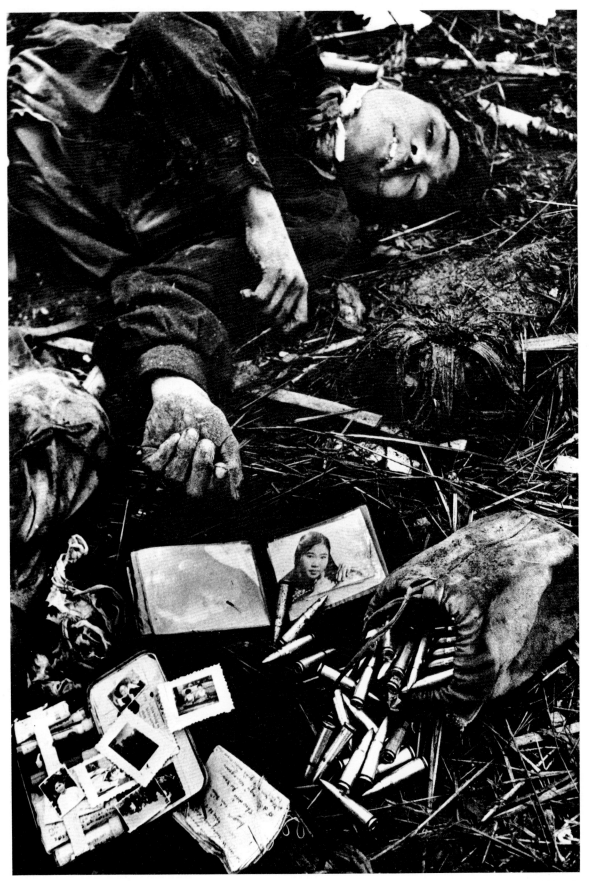

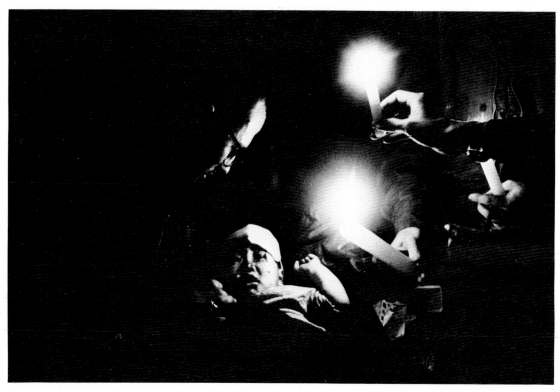

42 1968

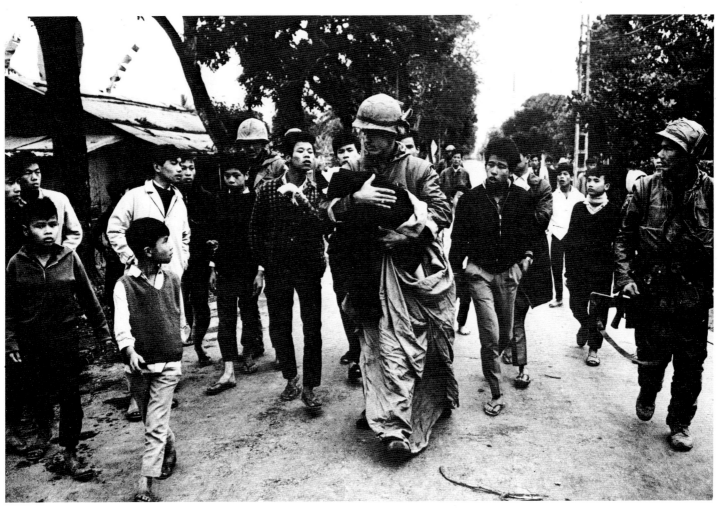

1968 43

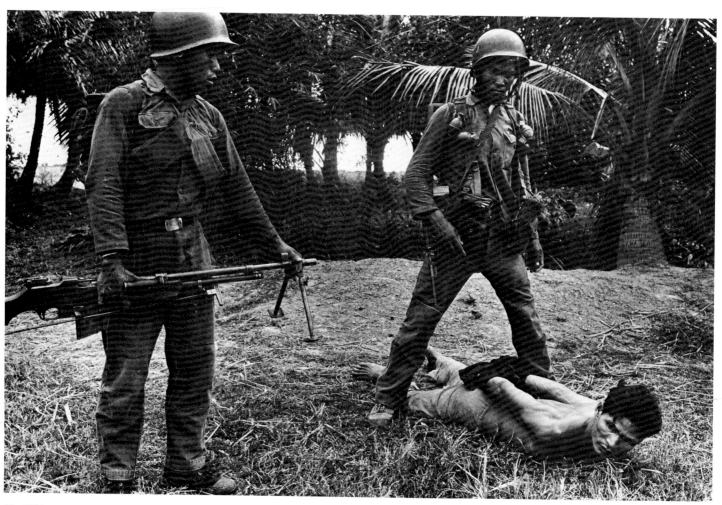

44 1964

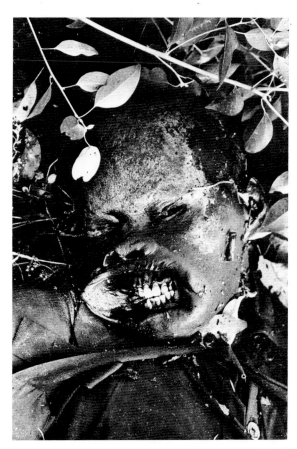

1968 46

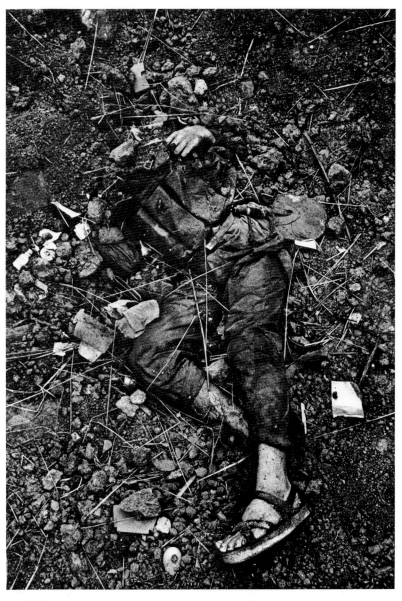

45 1968

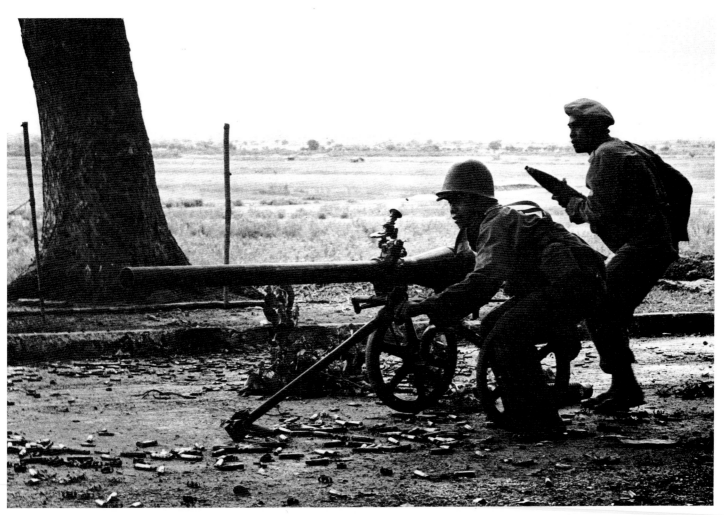

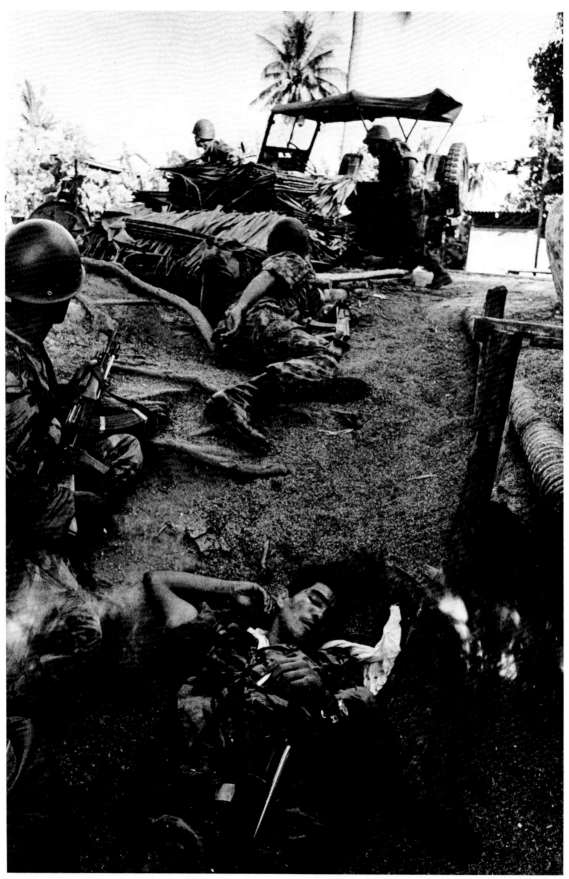

48 1970

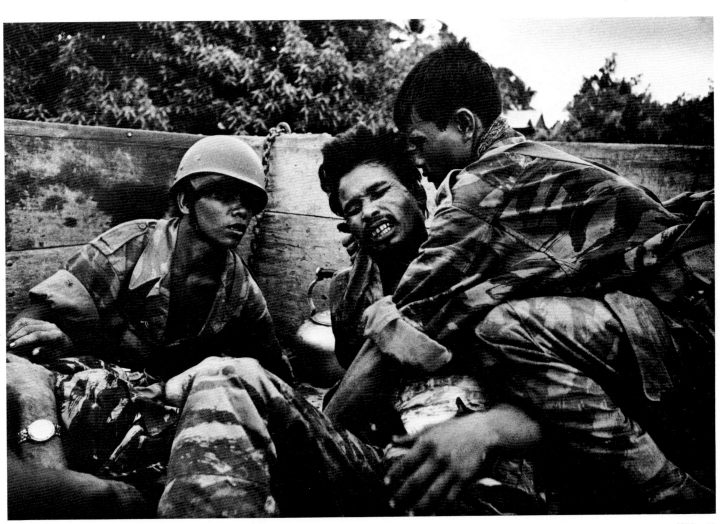

1970 49

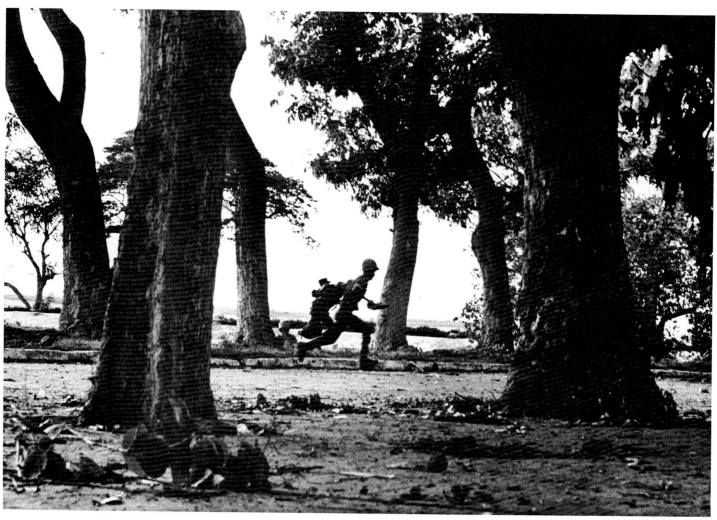

50 1970

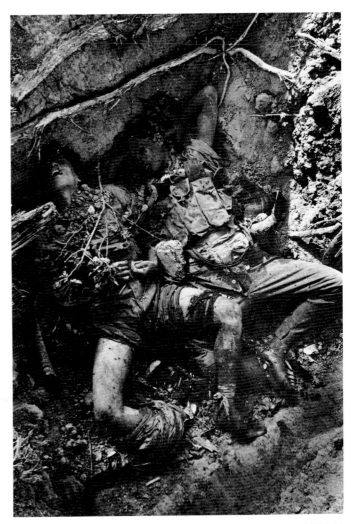

1970 52

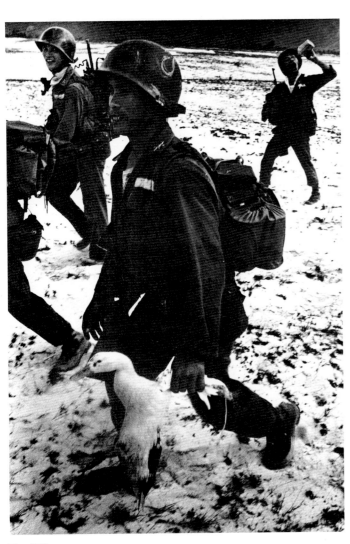

51 1967

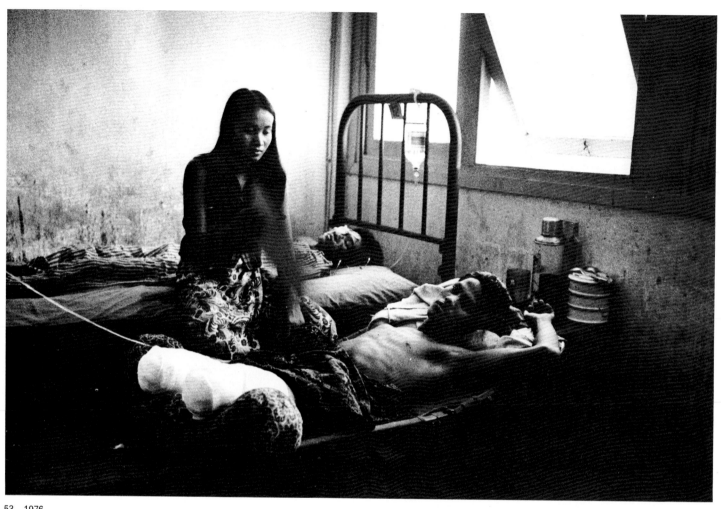

53 1976

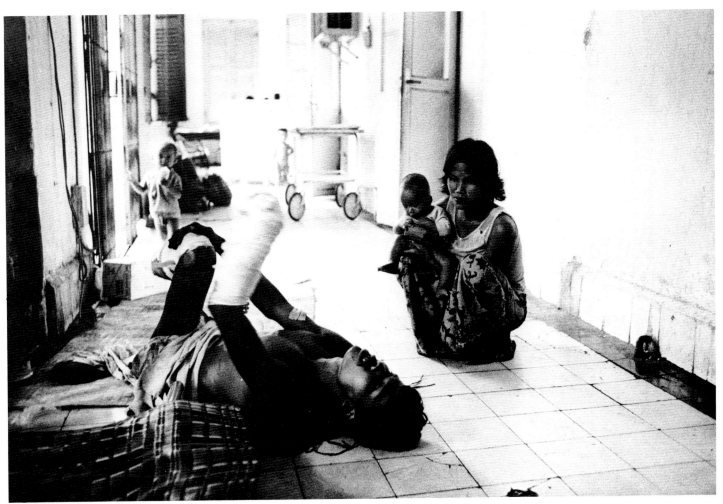

1976 54

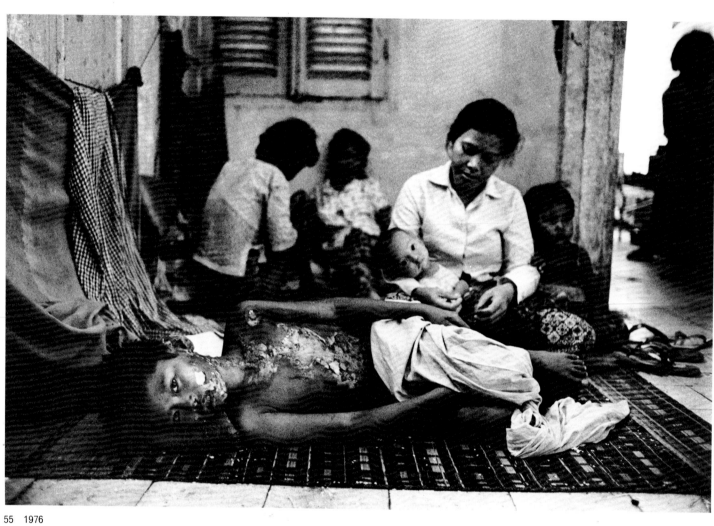

55 1976

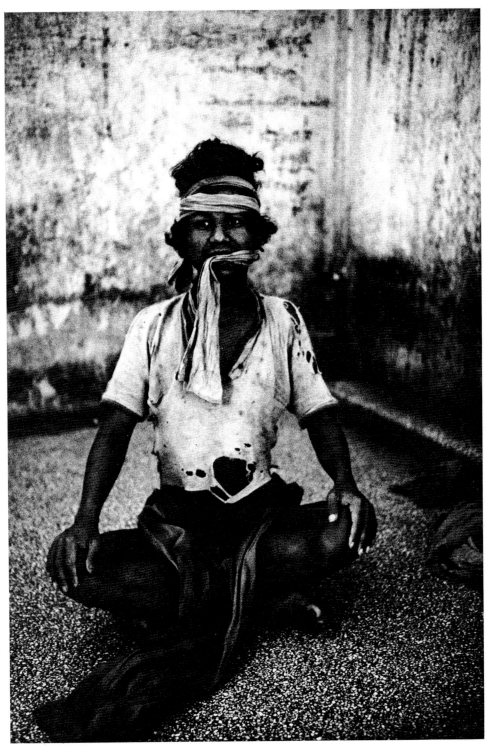

1976 56

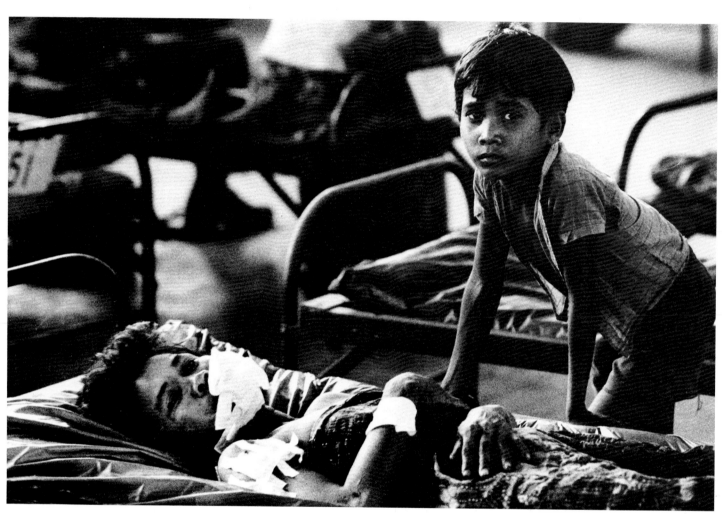

57 1976

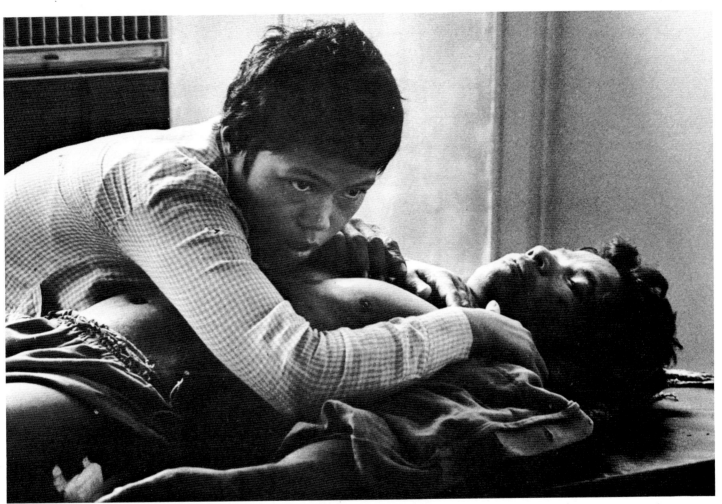

1976 58

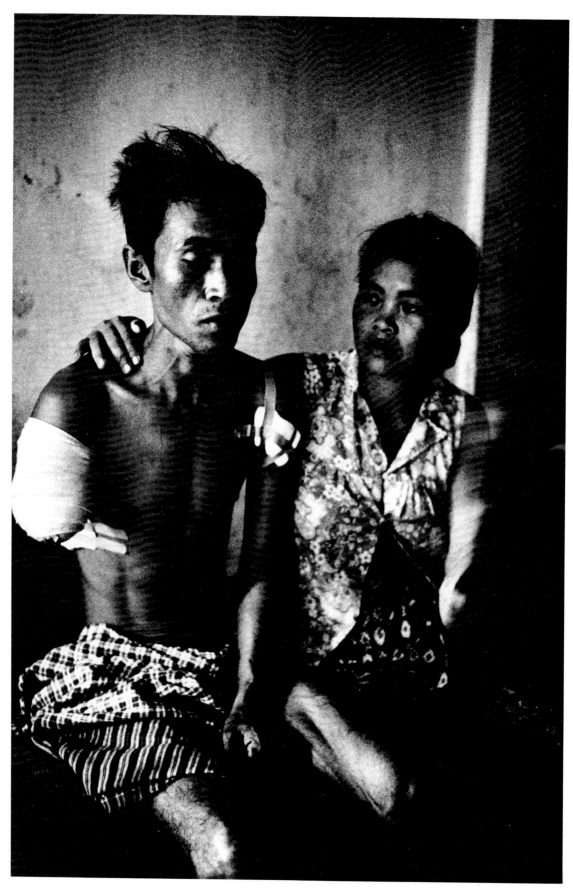

59 1976

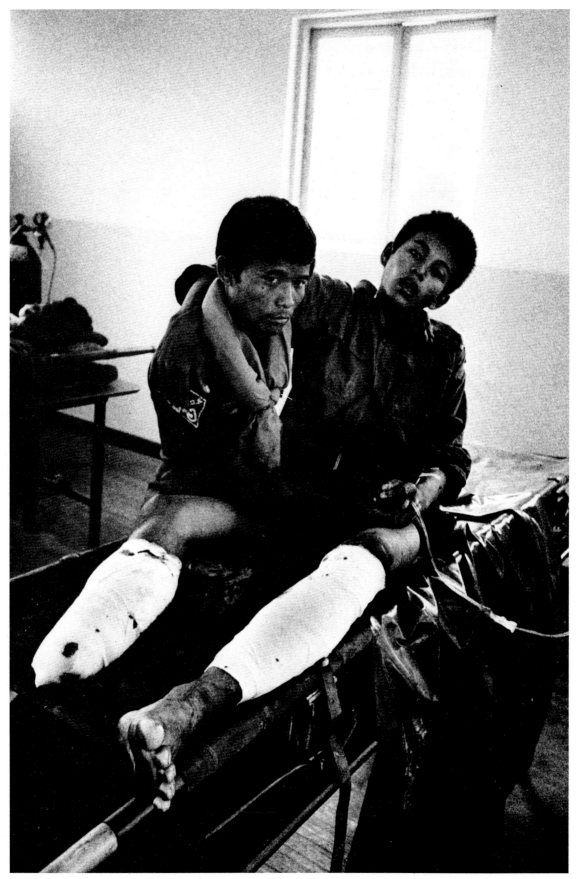

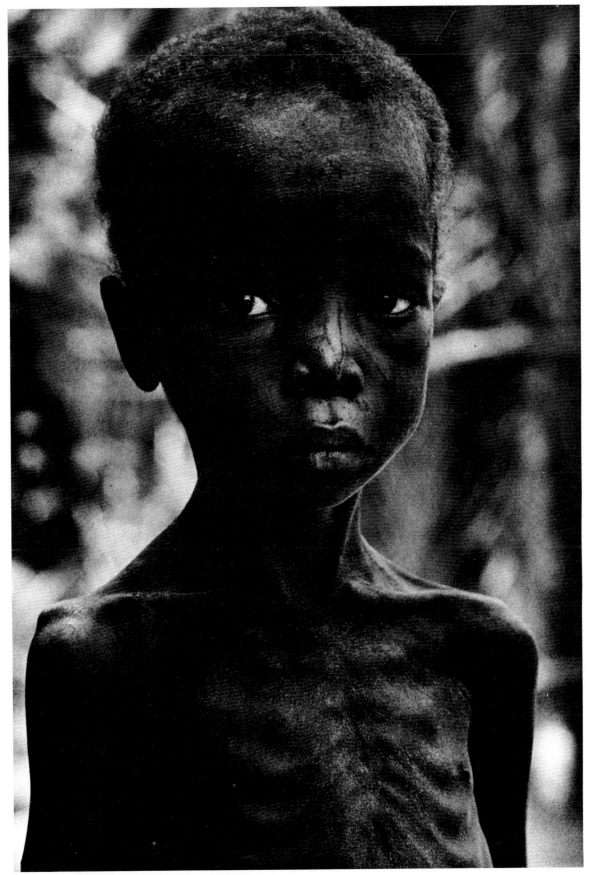

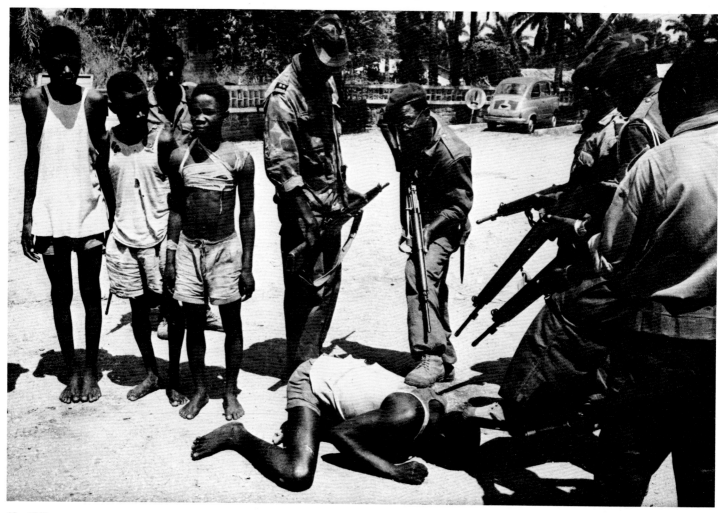

62 1964

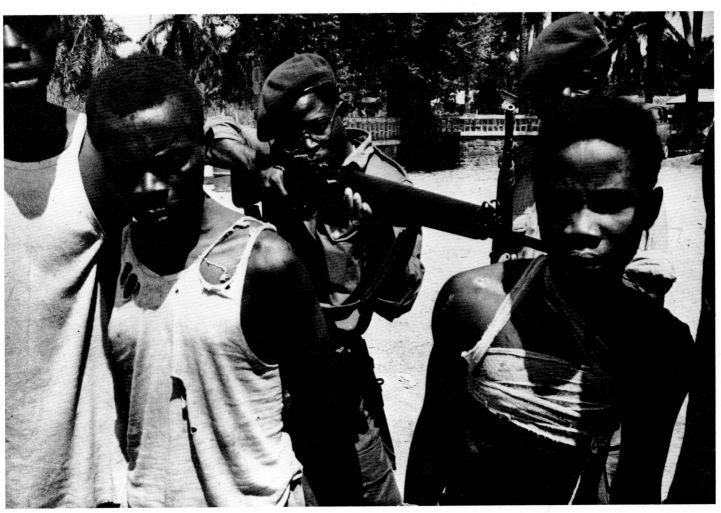

1964 63

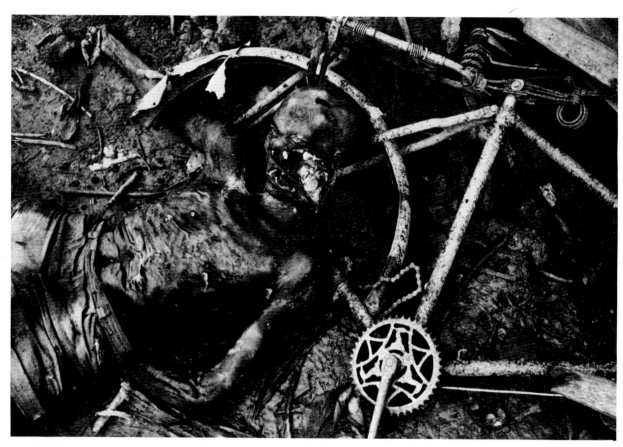

64 1964

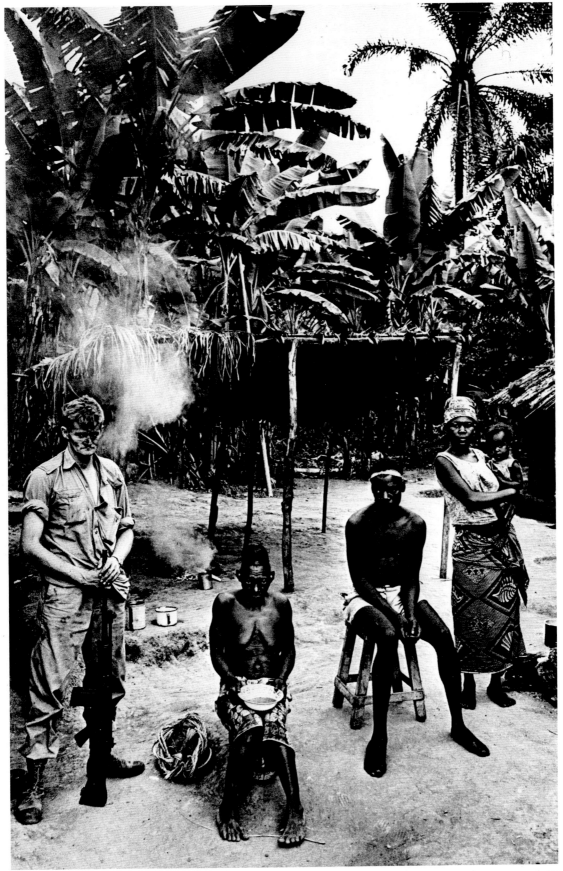

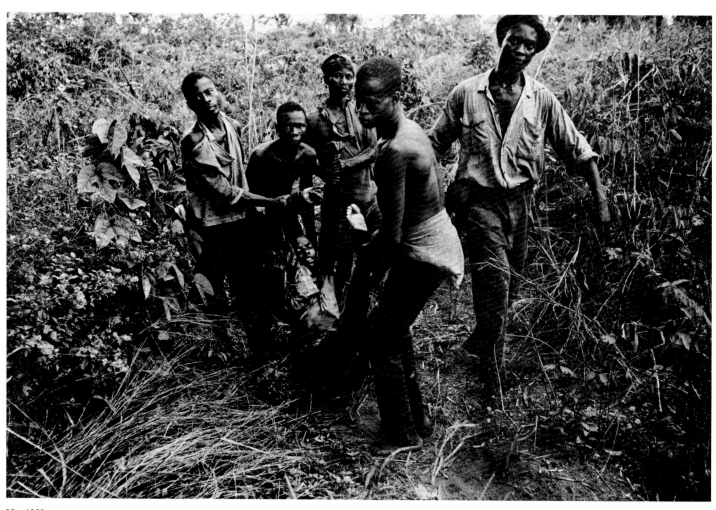

66 1969

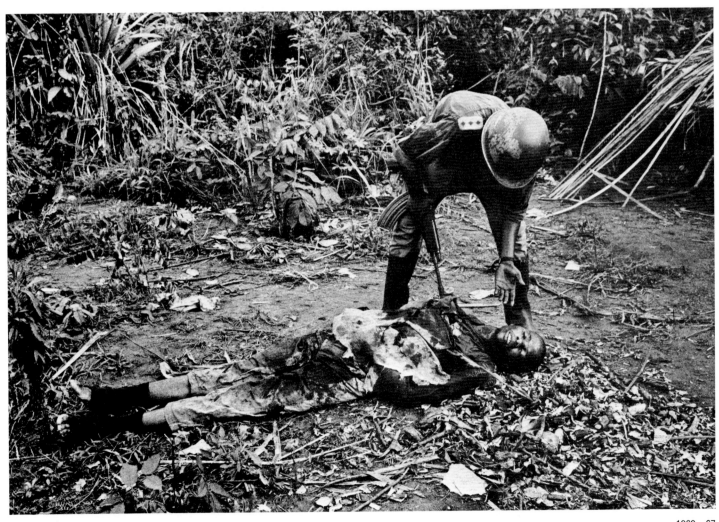

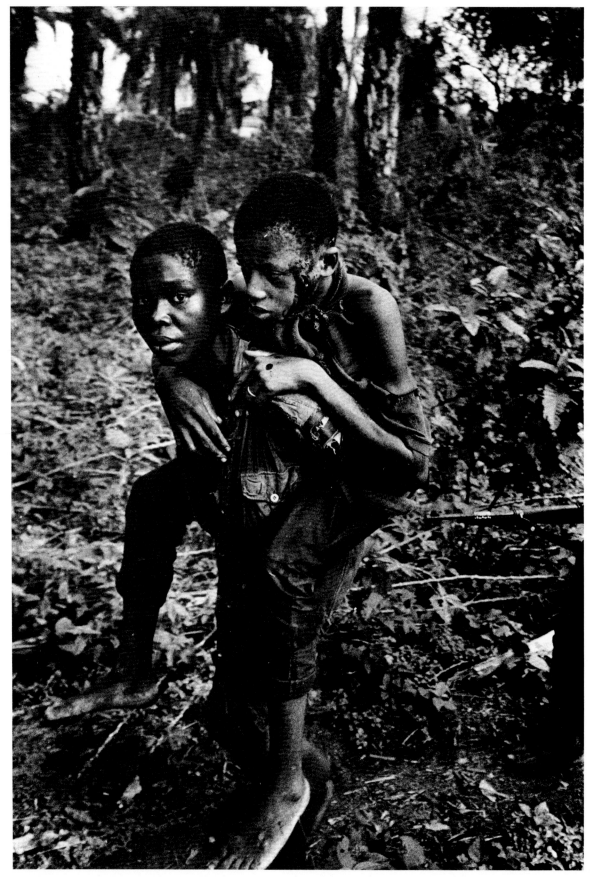

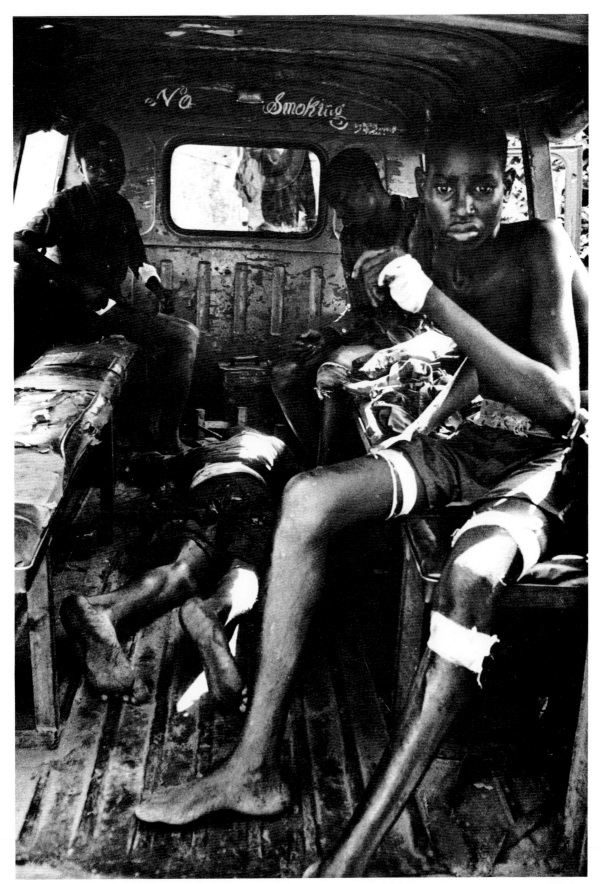

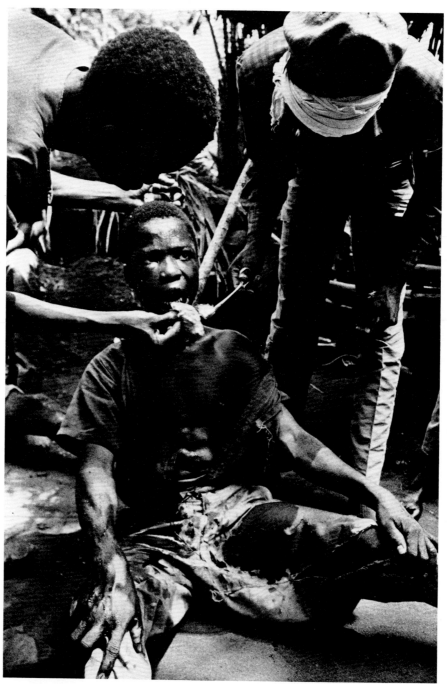

70 1969

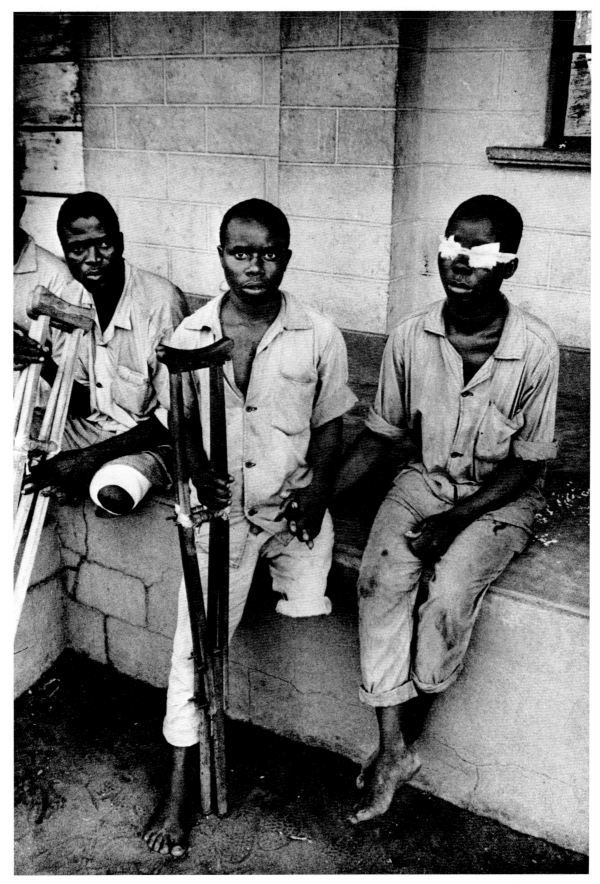

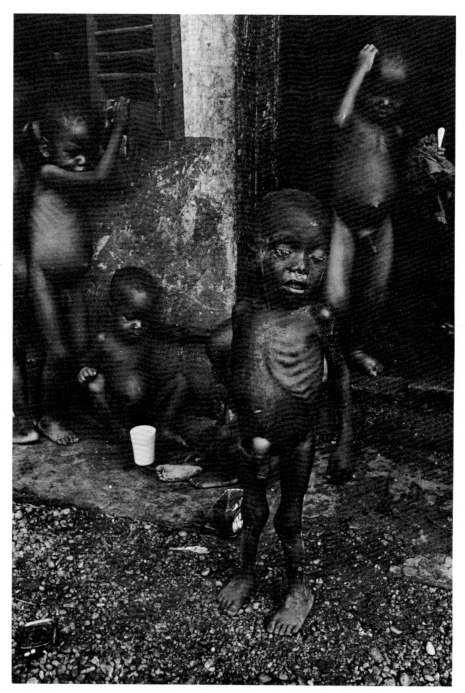

72 1970

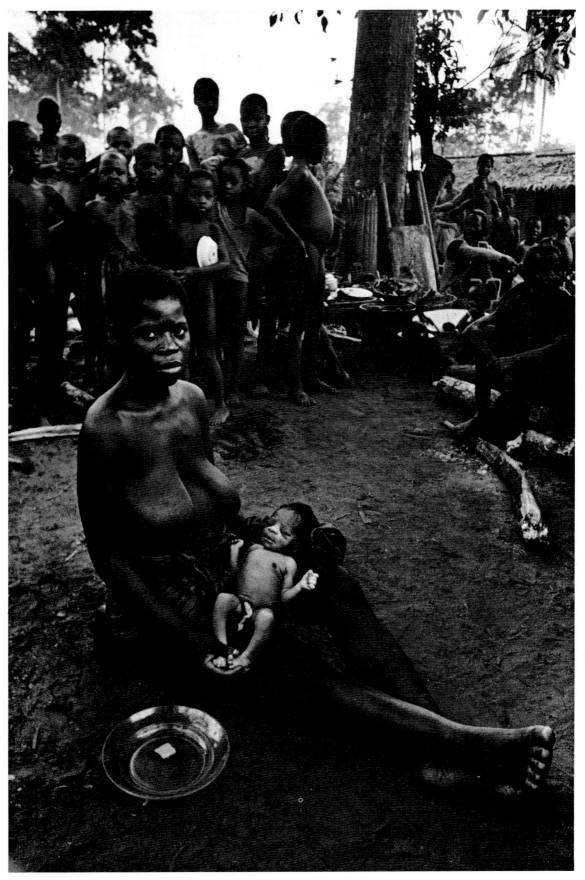

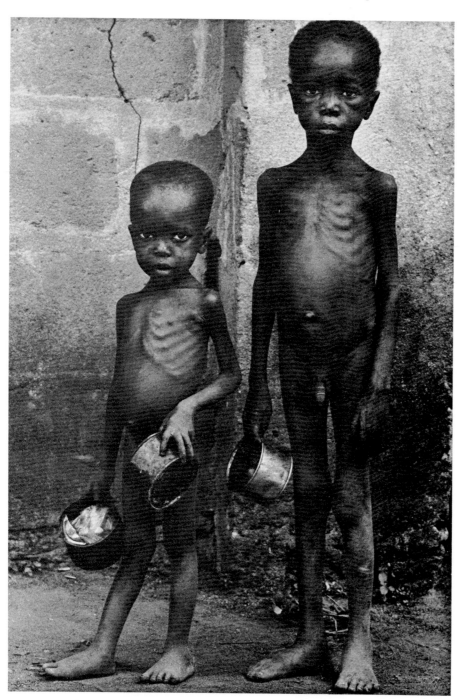

74 1970

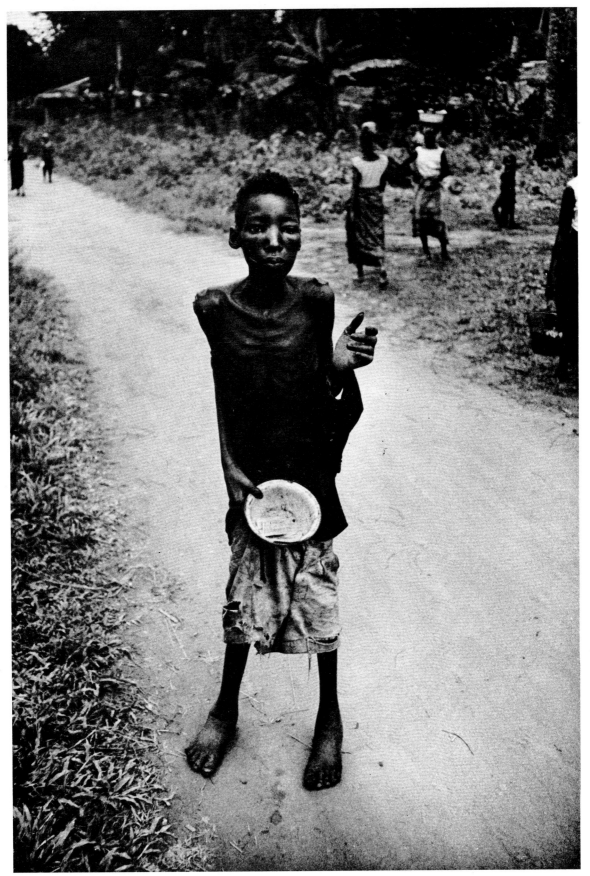

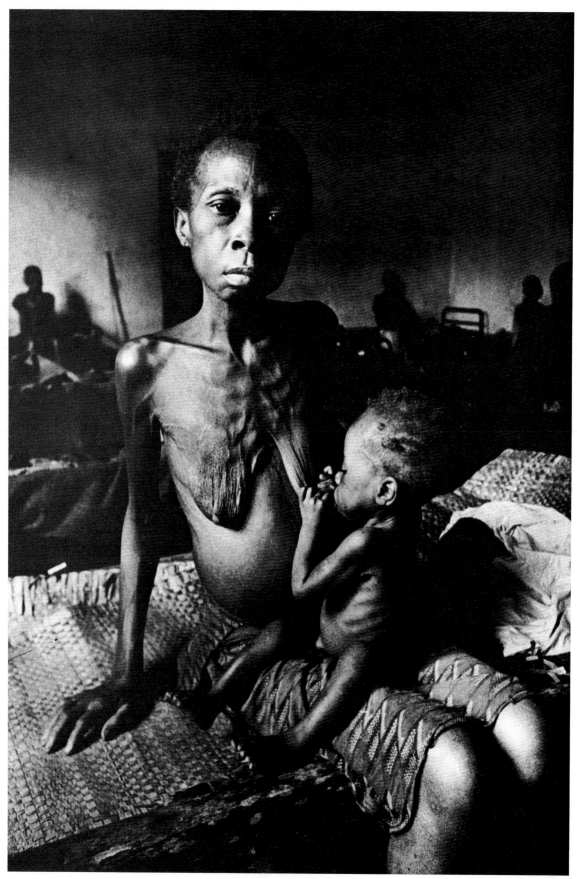

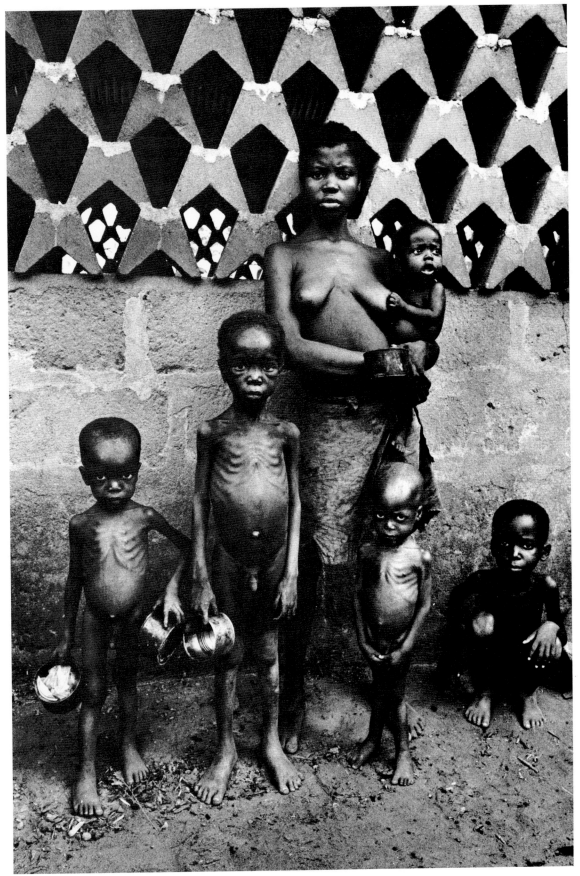

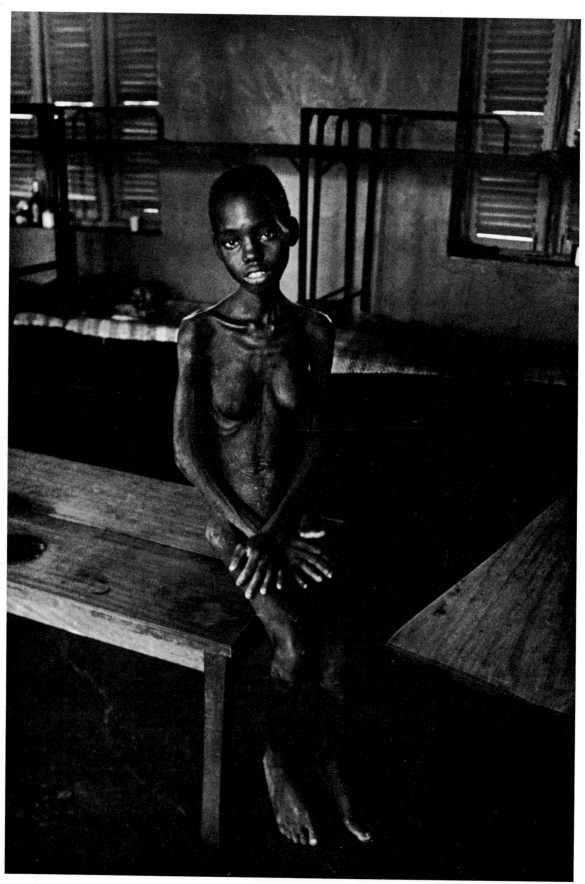

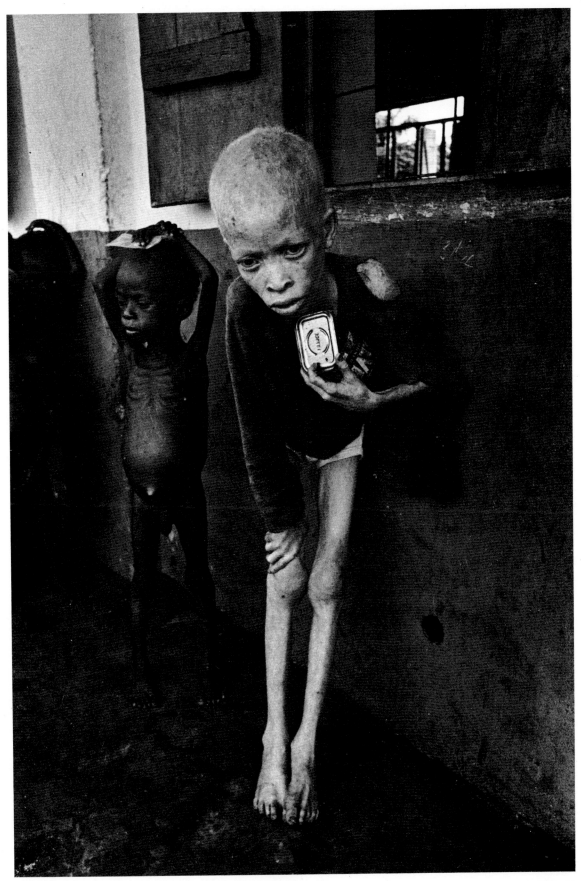

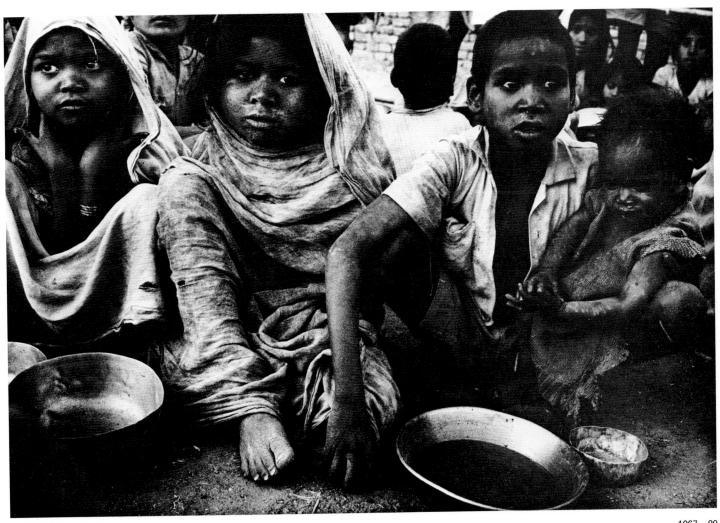

1967 80

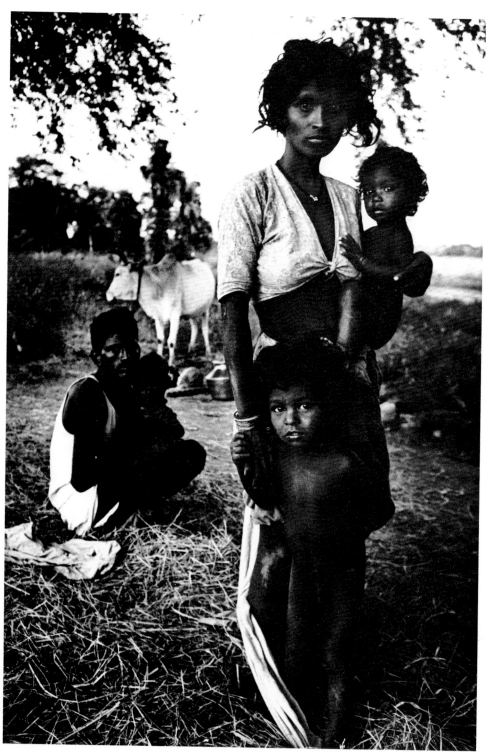

81 1965

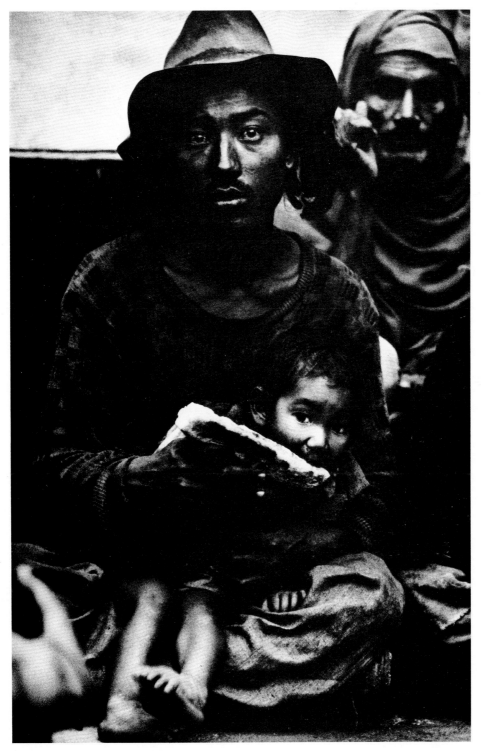

1965 82

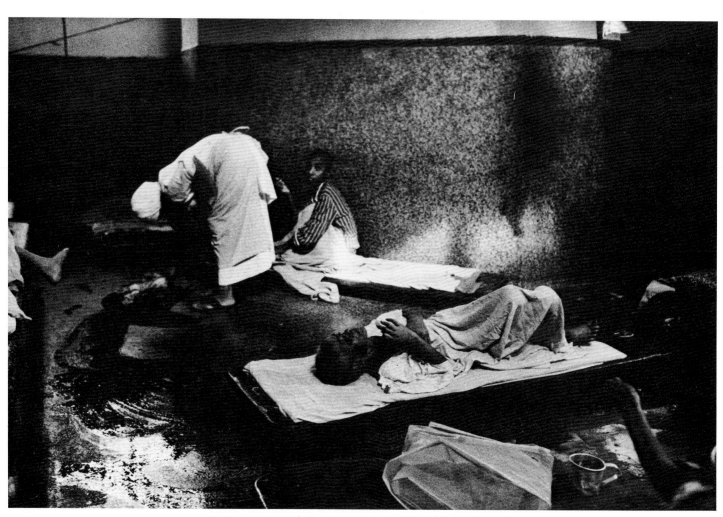

83 1970

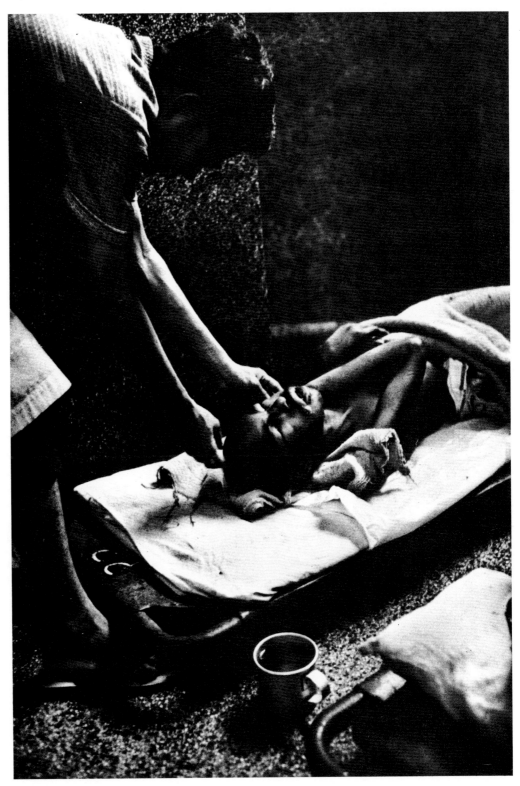

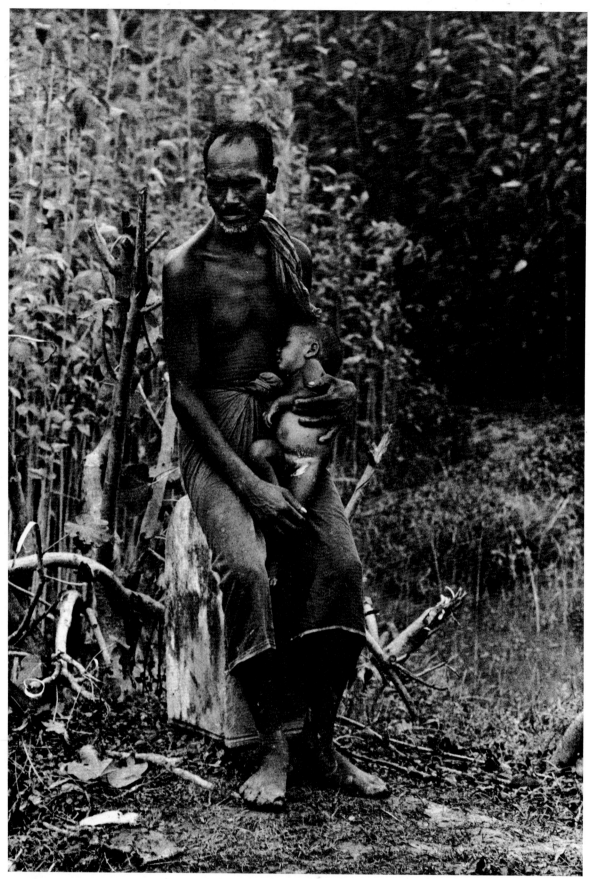

85 1971

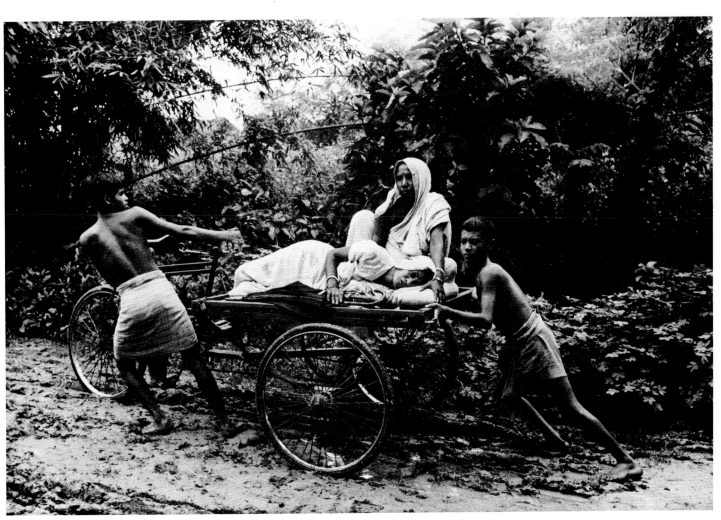

1971 86

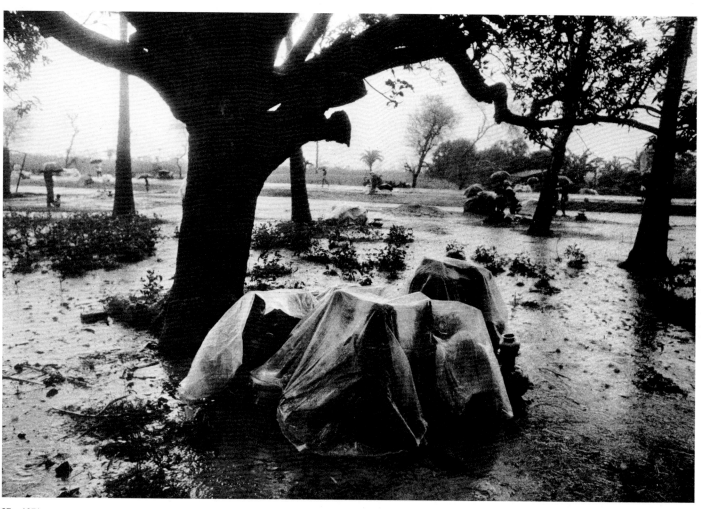

87 1971

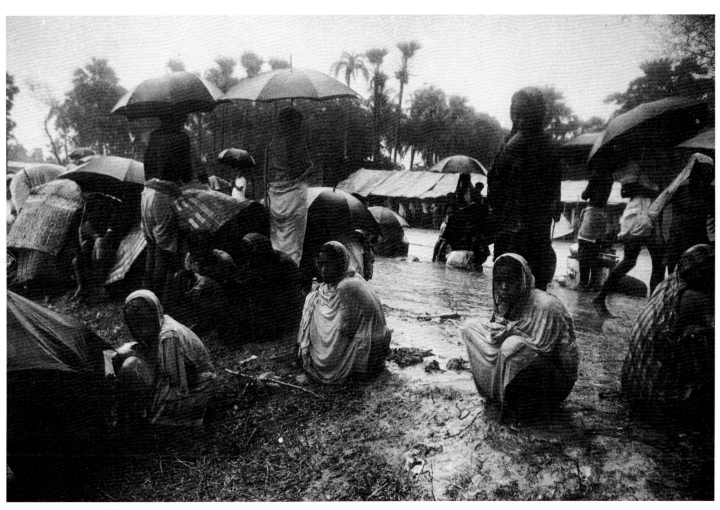

1971 88

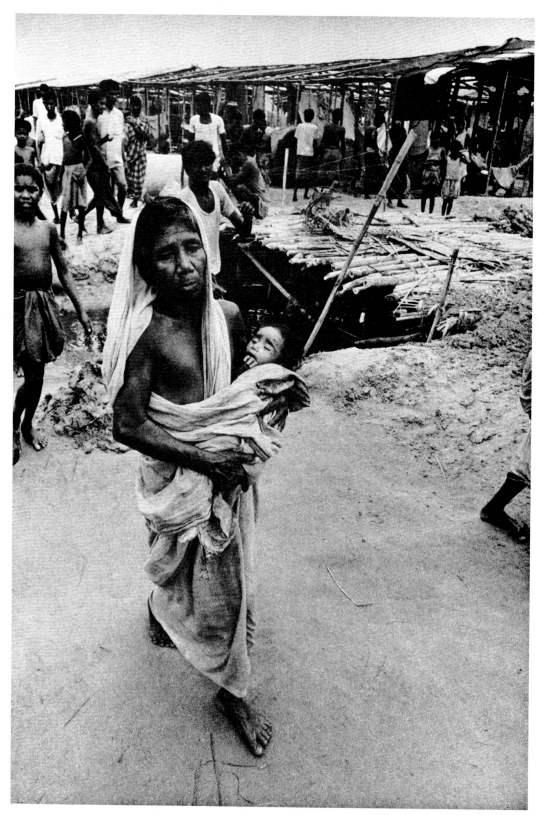

89 1971

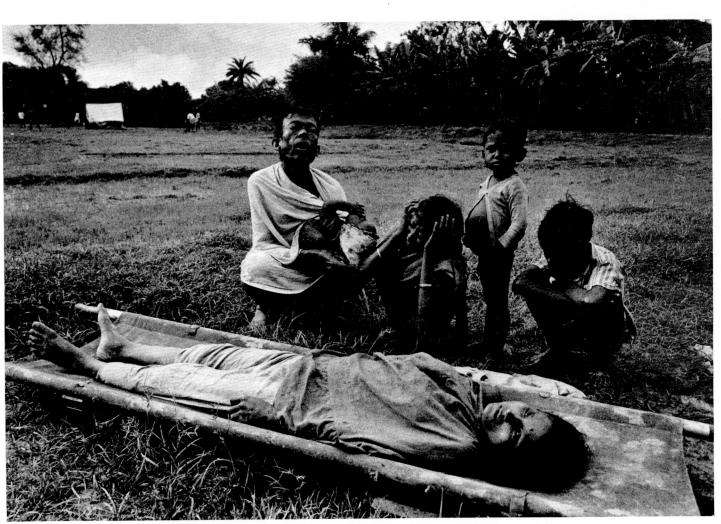

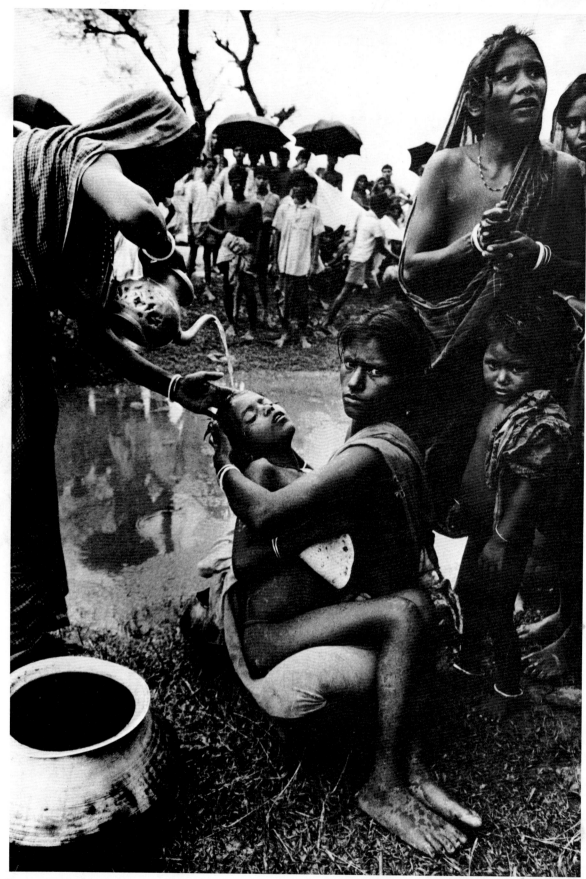

91 1971

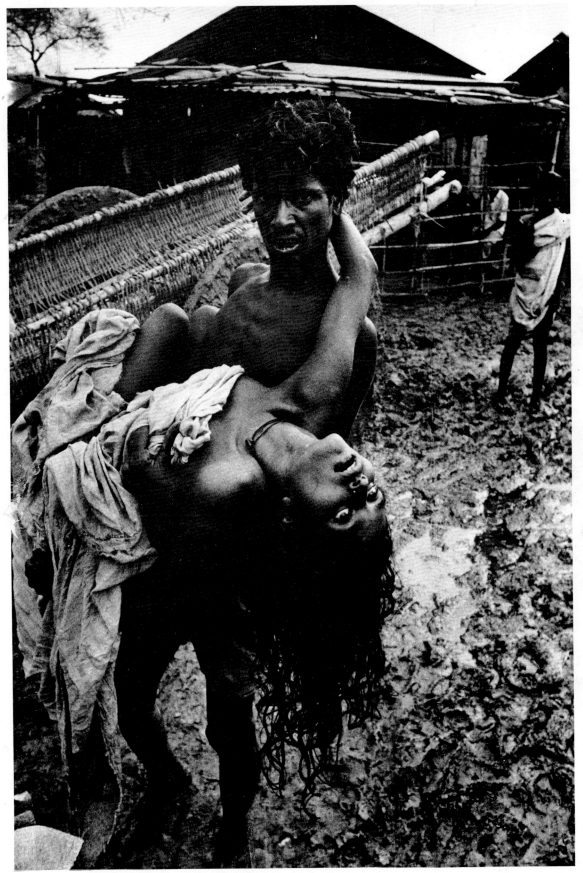

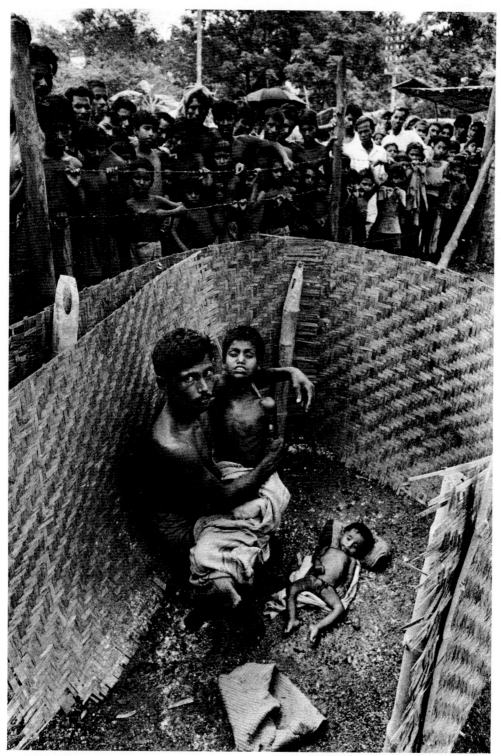

93 1971

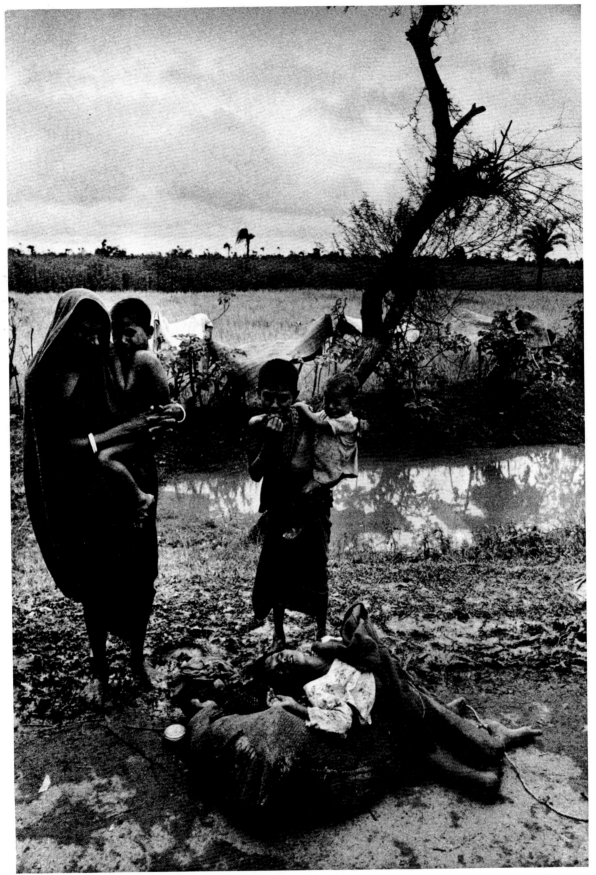

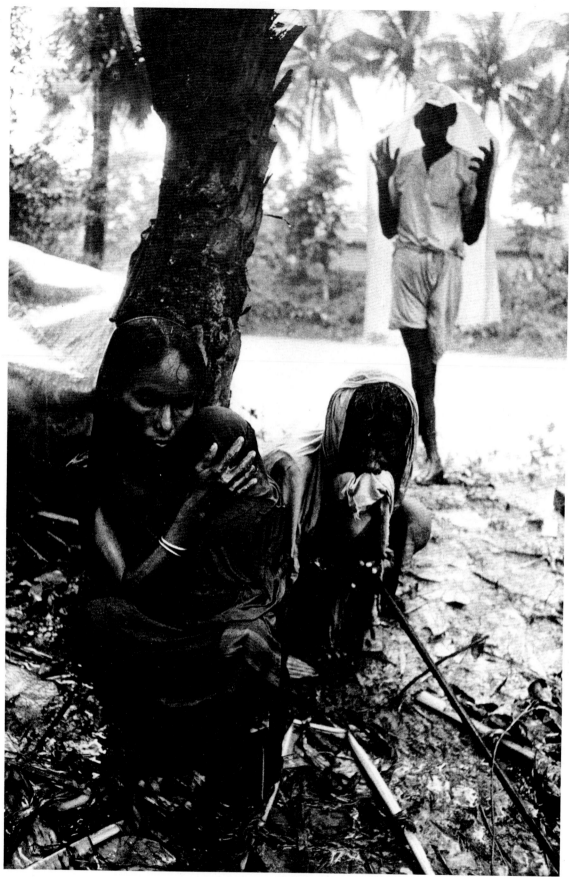

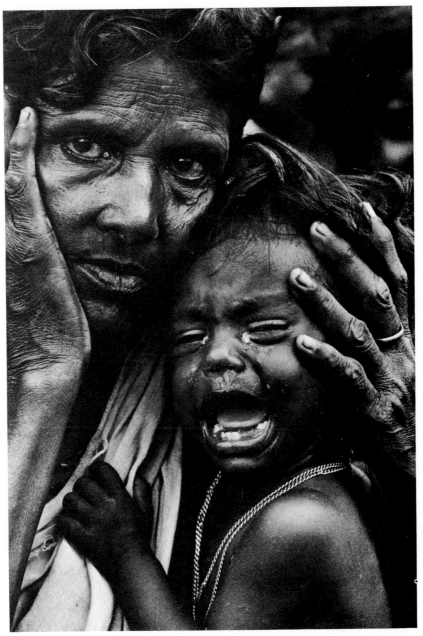

1971 96

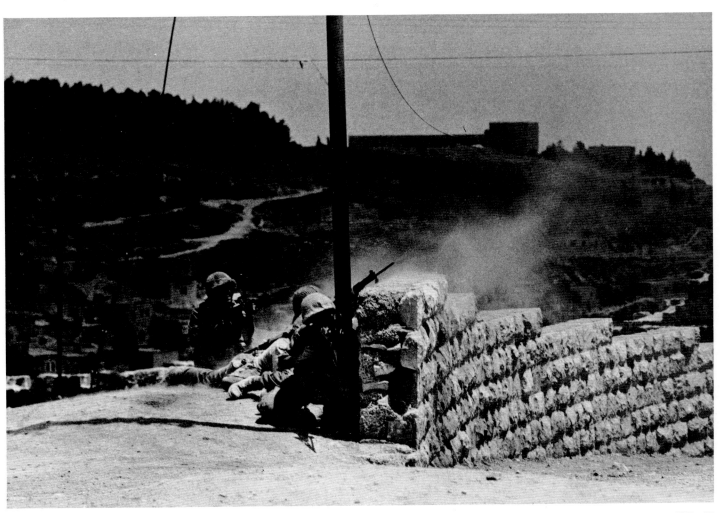

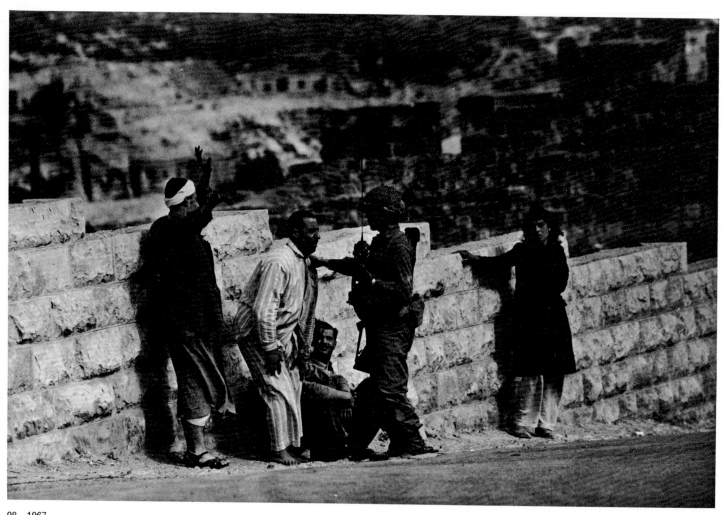

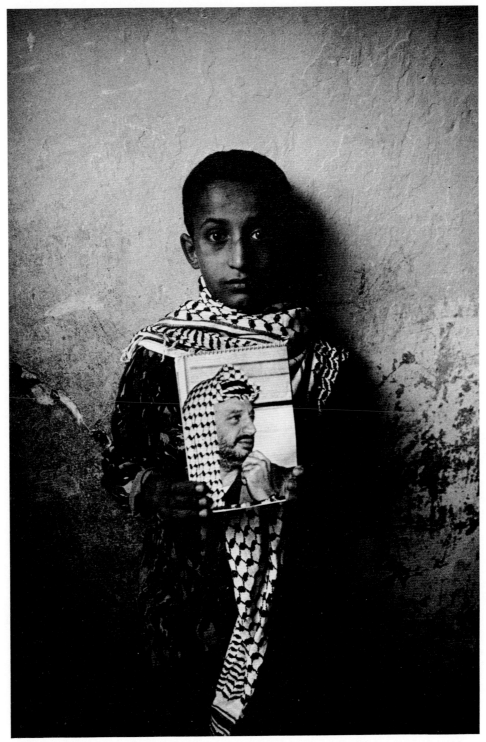

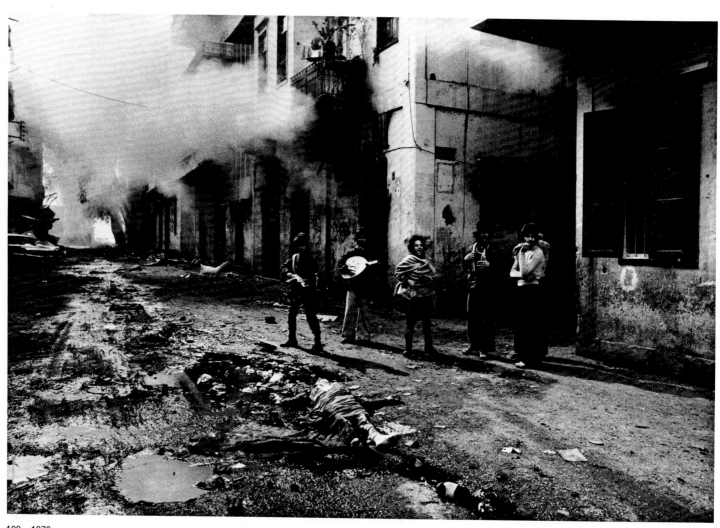

100 1976

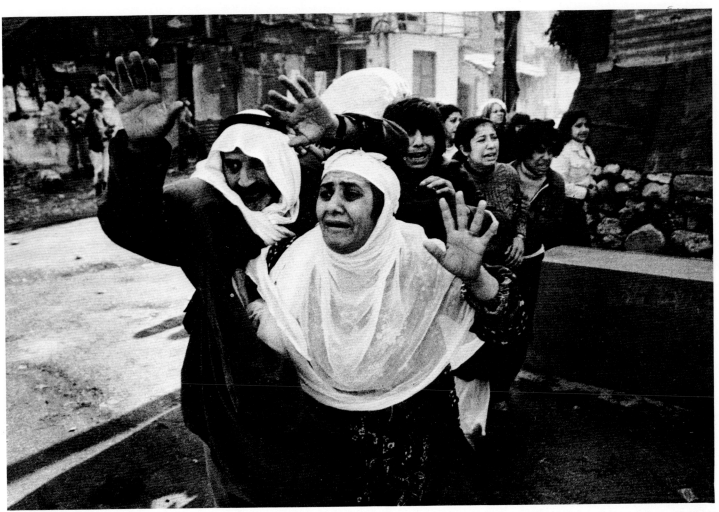

1976　101

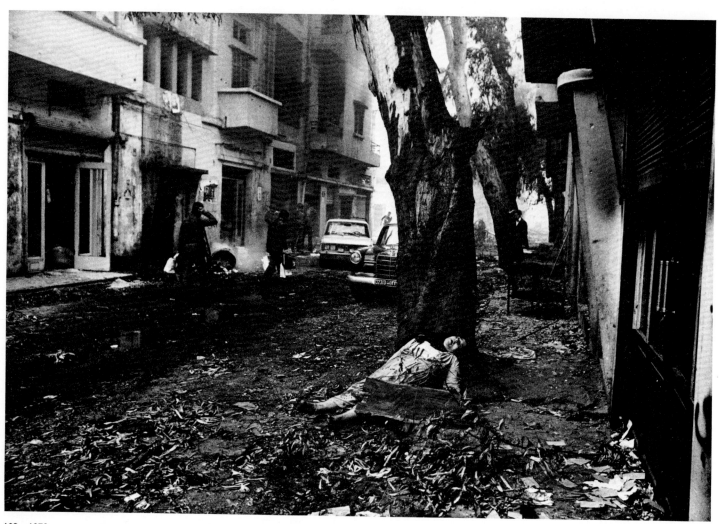

102 1976

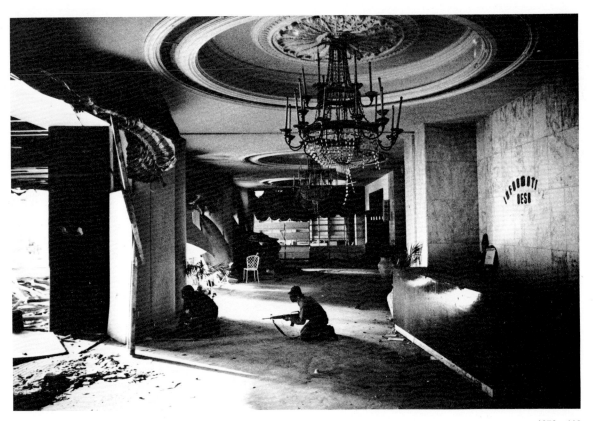